June 2012

Happy Birthday Kate!
We hope this brings you
a little inspiration.

Lots of Love

Mantha
+
Ad

× ×

Type Image

Barbara Brownie

Type Image

Copyright © Barbara Brownie

First Published in the United States of America, 2011

First Edition

Gingko Press, Inc.

1321 Fifth Street

Berkeley, CA 94710, USA

Phone (510) 898 1195 / (510) 898 1195

email: books@gingkopress.com

www.gingkopress.com

ISBN: 978-1-58423-442-5

Design: Allen Hong

Chief Editor: Vivian Lei

Copy Editor: Evelyn Wu

Printed in China

In recent years,
the alphabetic keyboard has
become a tool for image-making.
Alphabetic characters are now not only
considered in terms of their potential to display
linguistic information, but also their potential to act
as artists' marks. *Type Image* presents a collection of
contemporary works which challenge the divide between
type and image. These examples use typed characters
in the construction of pictorial forms. Distinct from
other forms of experimental typography, the aim of
these works is not to decorate letterforms, but
to utilise them as the component parts of a
more significant pictorial whole.

Contents

1 Introduction

For Ferdinand de Saussure, the founding father of modern semiology, the sole purpose of type was to convey linguistic meaning[1]. Numerous typographers have designed type according to Saussure's assertion that the typed or written word should be solely a representation of speech. During the Modernist era, it was felt that the most ideal type directly and efficiently referred to spoken language[2]. In 1930, Beatrice Ward compared type to a crystal goblet: an invisible container for language. Both Ward and Saussure felt that the form and appearance of written word should go unnoticed: that its linguistic content should be prioritized over visual style.

At the Bauhaus, Herbert Bayer designed his *Universal* typeface (1925), specifically absent of ornamentation. His type was a blank canvas, expressing nothing, refusing to distract from linguistic function. Meanwhile Jan Tschichold's *The New Typography* (1928) asserted that "a good typeface has no purpose beyond being of the highest clarity"[3]. It should be simple, clear, and above all, should not distract from linguistic signification. All personal expression should be removed, and any element of decoration eliminated.

By this time, however, the typed word had already demonstrated its potential to communicate pictorially as well as linguistically, and even as Bayer, Tschichold and Ward asserted the supremacy of function over aesthetics, designers were creating type that had more in common with image than with speech. Guillaume Apollinaire's *Calligrammes* (1913-1916) present both pictorial and linguistic meaning simultaneously. They communicate two messages: iconic and linguistic. Having parallel interpretations, they can be read as type or viewed as image, and the audience may switch between the two alternative readings[4]. The first reading, at a micro level, is narrative type, and the second reading, at a macro level, is an image. The image component may draw attention to a particular part or particular interpretation of the linguistic content, thereby reinforcing the linguistic message, or, on other occasions, it may be independent of the linguistic meaning, communicating an entirely different message.

The De Stijl movement helped to distance the printed word from the perception of type as a mechanised version of written script. De Stijl type was not constructed from strokes, but from geometric forms. More significantly to this investigation into the typed image, De Stijl's geometric primitives were the same as those used to construct images. Designers including Theo van Doesburg used an interchangeable array of polygons to construct text and image, proving that, at least at the point of construction, type and image can be considered in the same terms. Van Doesburg's cover for the first edition of De Stijl magazine (published from 1917 to 1931) presents type constructed from rectangular primitives. The same primitives are used in the construction of the abstract pictorial arrangement beneath the type. This type operates in an opposite manner to Apollinaire's *Calligrammes*, by communicating pictorially at a micro level, and linguistically at a macro level.

1 Saussure, Ferdinand de, Harris, Roy (translator), Course in General Linguistics, Duckworth, London, 1983, p. 24.

2 Warde, Beatrice, 'The Crystal Goblet', 1930, in Armstrong, Helen (ed.), Graphic Design Theory, Princeton Architectural Press, NY, 2009, pp. 39-43.

3 Tschichold, Jan, 'The Principles of the New Typography', 1928, in Heller, Steven and Meggs, Philip B. (eds), Texts on Type, Allworth Press, 2001, pp. 115-128. p. 118.

4 Gross, Sabine, 'The Word Turned Image: Reading Pattern Poems', Poetics Today, Vol. 128, No. 1 (Spring 1997), pp. 15-32, p. 17.

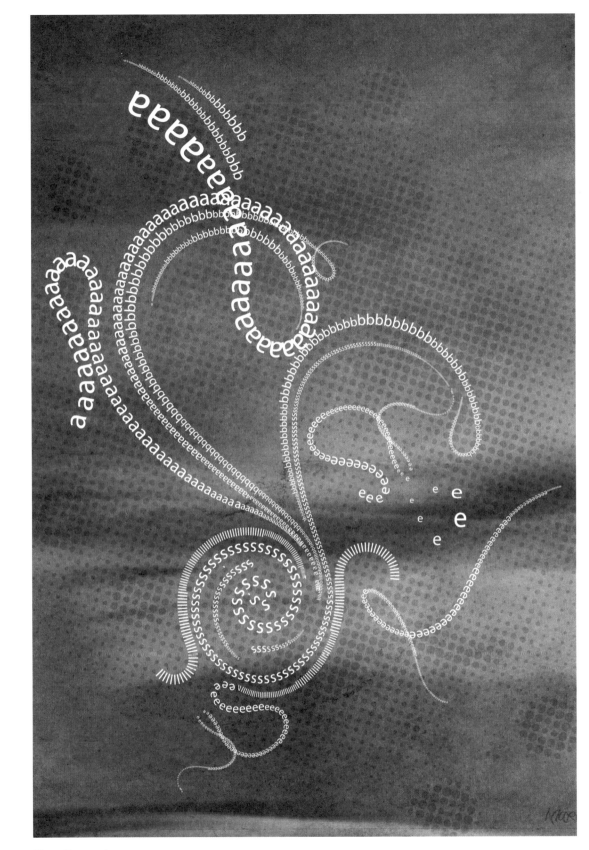

Mara Hernandez
Assemble
2009
avantexte.com

In interwar Europe, communication across language barriers demanded more than clear typefaces. In order to effectively convey a message to an international audience, an intuitive method of communication needed to be developed: a diagrammatic language which could transcend linguistic and educational boundaries. In 1936, Otto Neurath published *ISOTYPE*, a system of pictures intended as a substitute for written language, wherever the audience was likely to be international or illiterate[5]. *ISOTYPE* is as structured as other languages, but is distinct from conventional spoken or written language in that it contains iconic rather than arbitrary signs. Like words in a written sentence, *ISOTYPE* symbols can be grouped to convey a cumulative message, and, like written words, symbols must be presented in the correct order to make sense. An arrow next to another symbol could suggest motion, but an arrow alone would be meaningless (much like written or spoken verbs, which commonly require association with a noun in order to be made concrete). Like much conventional language, *ISOTYPE* is referential, describing objects and events beyond itself. It is entirely informative, designed to communicate concrete data. Other forms of language, particularly poetic language, communicate abstract ideas which are more difficult to convey through diagrammatic systems. Poetic language, rather than directly describing events beyond itself, aims to draw attention to the word itself. This elevates the written or typed word from a "vehicle for thoughts" to an "object in [its] own right[6]".

Much like poetic language (such as metaphor or rhyme), visual properties can be used to intervene in the relationship between the typed word and its linguistic meaning. American posters of the 1960s and 1970s embraced the hippy culture that began to emerge in San Francisco. When incorporating typography, these posters often did not use type, favouring hand-drawn writing. In imitation of Art Nouveau typography, this hand-drawn lettering was ornate and often irregular. In many examples, it was distorted to fill the silhouette of an image. Legibility was sacrificed in favour of style. Although the linguistic content is referential, this lettering draws attention to itself by operating pictorially, asserting its difference from "plain" type.

From the 1970s, typographers began to reassert their desire to express individuality through type, and to treat typographic design as a creative rather than logical process. Wolfgang Weingart proposed that typography should be considered an art, not a science, and that "understanding the message was less dependent on reading" than typographers had previously thought[7]. Weingart, and among others,

Edward Fella, broke away from the grid and began to treat the printed page as a free canvas, producing unconventional typographic compositions using unpredictable combinations of typefaces.

In the 1980s, letterforms became distorted or simplified until their linguistic identities were jeopardized. At *The Face* magazine, Brody systematically reduced linguistic forms to abstract shapes. He replaced the "A" in *The Face* with a triangle, and over six consecutive issues, gradually reduced the word "contents" to an arrangement of lines and crosses[8]. Brody had previously avoided the field typography, assuming it to be too restrictive[9]. This attitude manifested itself in the treatment of type as image. For each edition of *Fuse*, Brody created a new font, many of which were barely legible. Some occupied an awkward void between recognisable lettering and abstract forms: somehow familiar and seemingly typographic at first glance, but ultimately linguistically empty. With variations in size and colour, these fonts could be used in the construction of abstract pictorial compositions.

5 Crow, David, Left to Right: the Cultural Shift from Words to Pictures, AVA, Switzerland, 2006, p. 60.

6 Hawkes, Terrence, Structuralism and Semiotics, Methuen & Co. Ltd., London, 1977, p. 63.

7 Weingart, Wolfgang, 'My Way to Typography', 2000, in Armstrong, Helen (ed.), Graphic Design Theory, Princeton Architectural Press, NY, 2009, pp. 77-80, p. 78.

8 Poynor, Rick, No More Rules: Graphic Design and Postmodernism, Laurence King Publishing, London, 2003, p. 49.

9 Brody, Neville, cited in Wozencroft, Jon, The Graphic Language of Neville Brody, Thames & Hudson, London, 1988, pp. 15-18.

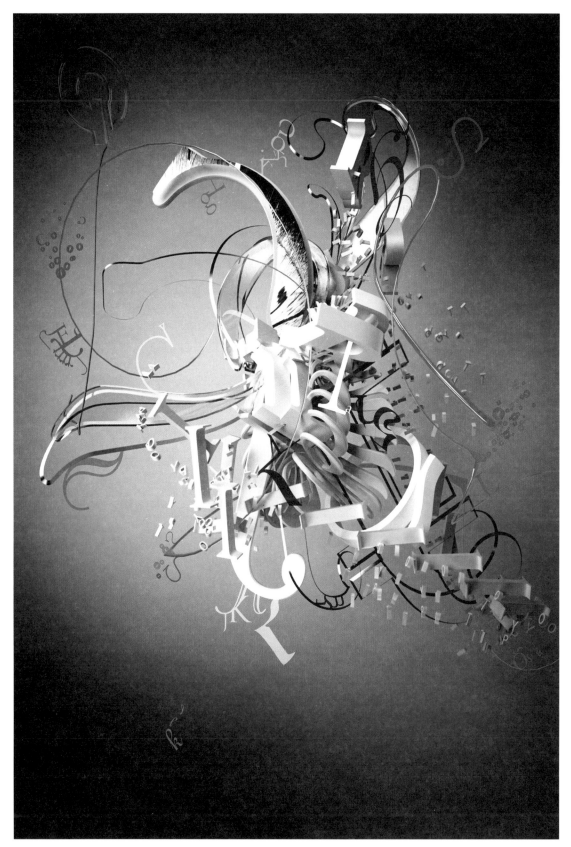

Christoph Bader
Letters are More than Words
2007
www.depotvisuals.de

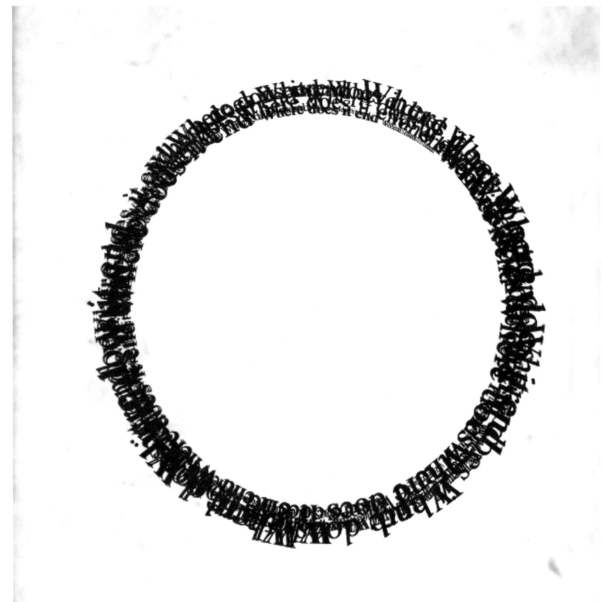

WHERE DOES IT END?

Mohammed Alshoaiby
Where Does It End?
2008

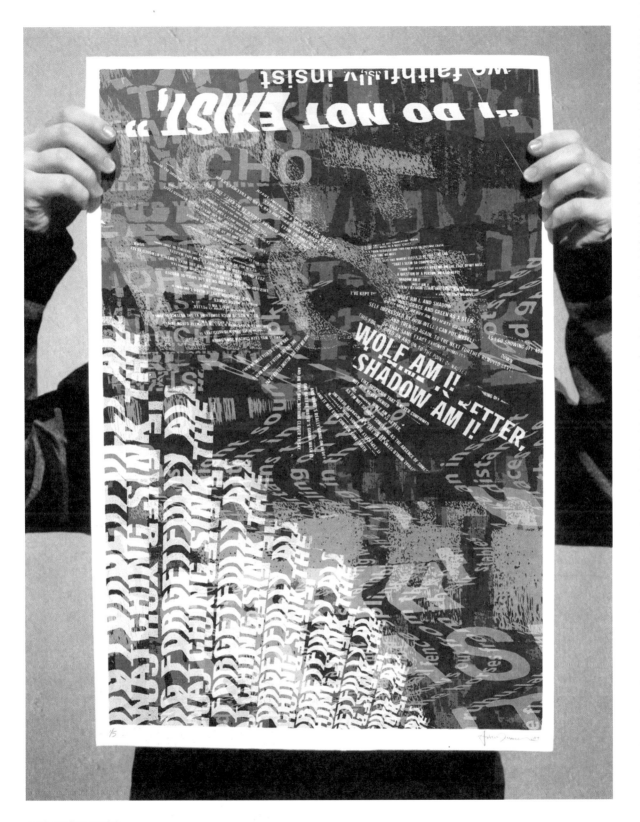

Andrew Dernavich
Brother Sister
2008
andrewdernavich.com

Alex Varaese
Secret Identity
2009
www.alexvaraese.com

David Carson, as art director of *Beach Culture* and *Ray Gun* magazines, experimented extensively with layout. With no design training, Carson worked intuitively, challenging or even contradicting established rules of "good design". Sliced, distorted and layered type ensured that Carson's typography expressed pictorially as well as linguistically. In many cases, type was completely illegible, denying any linguistic interpretation, forcing the type to perform as pattern, texture or image. His untitled 1993 poster, announcing a talk in Cincinnati, provides viewer with only the minimum information required for attendance at Carson's talk: the date and location. All other information is obscured by Carson's distortion of the type. Even Carson's own name is barely legible—the style alone signifies Carson's involvement to those who are familiar with his work. This chaotic arrangement is typical of Carson's typography, providing enough typographic information to indicate the presence of type, but not so much as to allow for that type to communicate linguistically. This simultaneously establishes and destroys expectations about how the poster should be received. Viewers attempt to seek out words within the chaos, but must settle for a confusing frenzy of overlapping letterforms.

Thanks to typographers such as Carson and Brody, and their willingness to challenge convention, our notion of type has come a long way since the days of Bayer and Tschichold. Contemporary practitioners are now able to challenge expectations: to present type with unexpected characteristics, in unlikely contexts. Type has been removed from the mundane domain of the monotone print, transposed into the dynamic worlds of image and screen. Contemporary type performs two functions simultaneously: it can operate as type and image, shifting between paradigms, and defying expectations.

Contained within the following pages are numerous examples of contemporary practice which challenge the conventional understanding of type, and blur the boundaries between type and image. These works are built on a foundation of experimental typography laid by the Postmodern typographers of the late twentieth century, who have understood that type can communicate pictorially as well as (or even instead of) linguistically. Many of these contemporary examples use pictorial form to reinforce linguistic meaning (as in *Karma* and *The Zebra Eye*, right), while others treat letterforms as entirely abstract (as in *Assemble* and *Letters Are More Than Words*, previous pages). However differently they may treat the letter, these images have a common goal, to turn type into image.

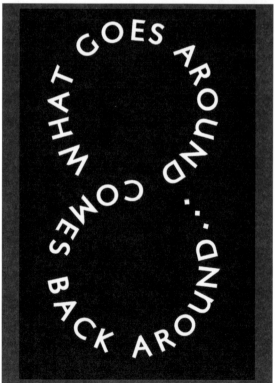

Amy Fedeska
Karma
2009
www.3LambsGraphics.Etsy.com

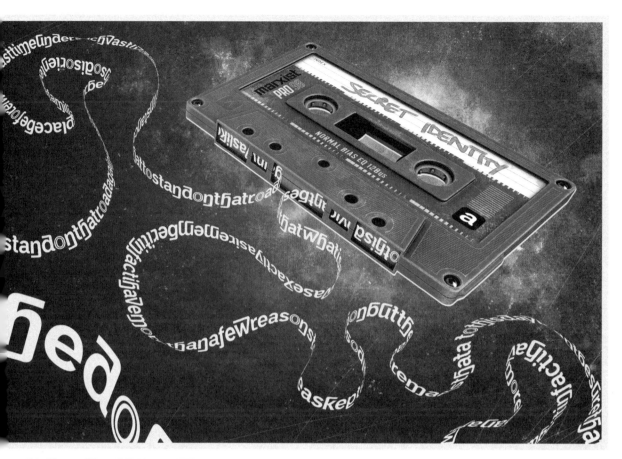

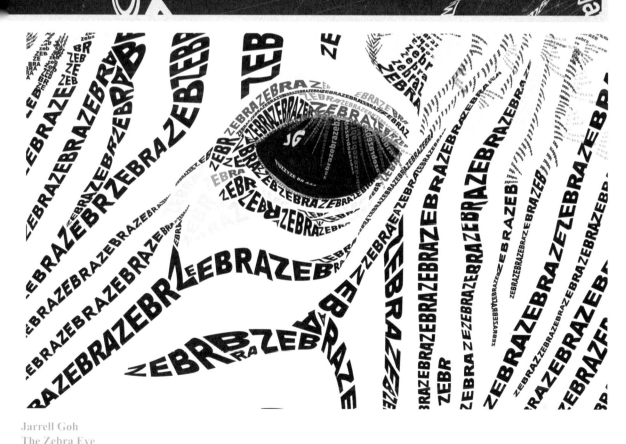

Jarrell Goh
The Zebra Eye
2007
fuzzyzebra.deviantart.com

Maria Piva
Grid Assignment
2008
mariapiva.deviantart.com

Jorunn Musil
Calendar
2010
www.jorunnmusil.com

2 Typographic Landscapes

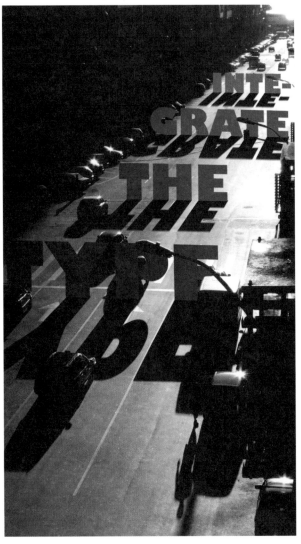

Chris Blakely
Integrate the Type
2007
www.groggie.com

Type has long been integrated into our environment. Particularly in urban environments, wayfinding is extensively aided by typographic information[1]. Text labels on maps and street signs, as well as business signage, allow us to locate ourselves and others, and to assess the nature of the landscape. Most signage, however vital in our understanding of space, is superficial. It exists only on the surface, to decorate and label the more significant buildings and objects which are constructed beneath. In typographic practice, the more fundamental parts of the landscape can be substituted for type. Type can form the very foundations of landscape, indeed an entire scene can be moulded and constructed from lettering. Here, type is more than superficial signage: the landscape is type through and through.

In Alex Engelmann's series of typography posters (right and overleaf), and Tang Yau Hoong's *I See The World in Three Dimensions* (overleaf), landscapes are constructed entirely of three-dimensional letterforms. In Engelmann's *Tower*, tall buildings are constructed from lines of type, stacked and wrapped into imposing cylindrical towers. Each letterform operates linguistically, remaining legible despite the unconventional use, but also functions as a load-bearing object, supporting the rows of letters which sit above it. This image draws parallels between the process of building and the process of writing.

Both writing and building involve stacking rows of forms in a meaningful order: in building, rows of bricks are stacked to form a larger construction, and in writing, rows of letters are arranged to form a narrative.

1 Silva Gouveia, A. P., Farias, P. L., and Souza Gatto, P. , 'Letters and Cities: reading the urban environment with the help of perception theories', Visual Communication, Vol. 8, No. 3, 2009, pp. 339-348, p. 344-345.

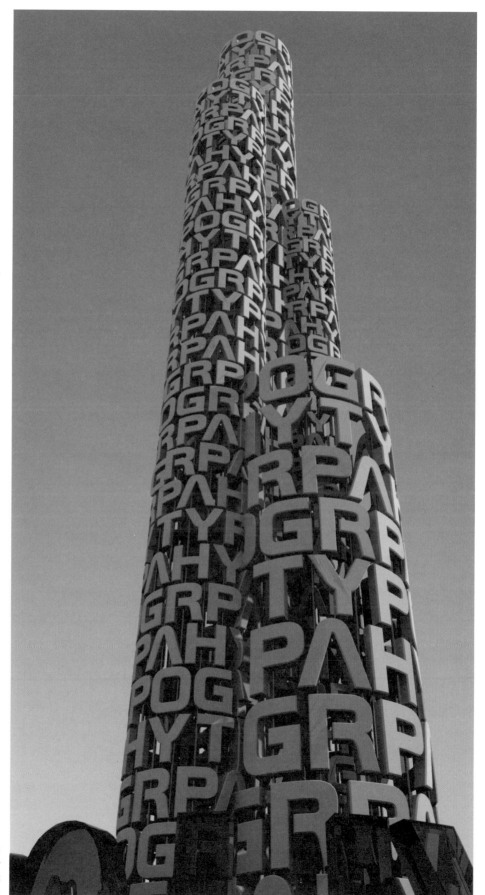

Alex Engelmann
Tower
2008
alexengelmann.com

Alex Engelmann
Abstract
2008
alexengelmann.com

Alex Engelmann
Horizon
2008

Tang Yau Hoong
I See The World In Three Dimensions
2009
www.flickr.com/tangyauhoong

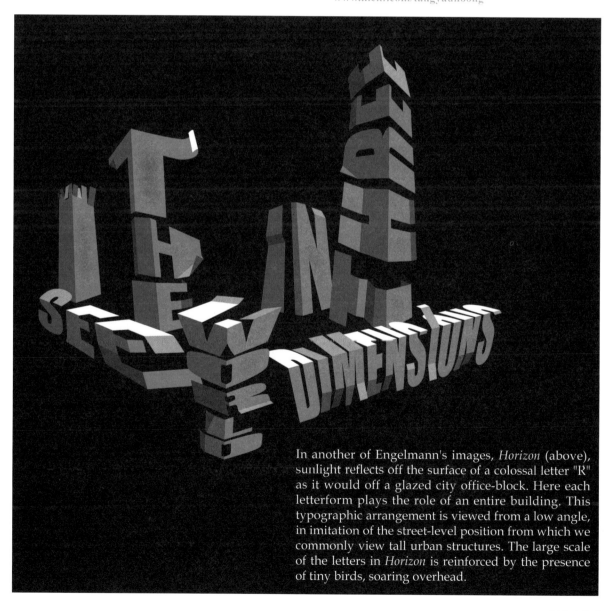

In another of Engelmann's images, *Horizon* (above), sunlight reflects off the surface of a colossal letter "R" as it would off a glazed city office-block. Here each letterform plays the role of an entire building. This typographic arrangement is viewed from a low angle, in imitation of the street-level position from which we commonly view tall urban structures. The large scale of the letters in *Horizon* is reinforced by the presence of tiny birds, soaring overhead.

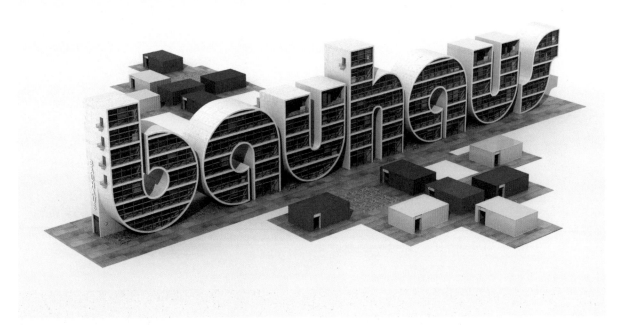

The Bauhaus' remarkable achievements in architecture and typography are acknowledged in Chris Labrooy's three-dimensional landscape (*Bauhaus*, above). Labrooy's image transforms ITC's Bauhaus typeface (inspired by Herbert Bayer's *Universal*) into an architectural structure. The boxlike buildings which stand in the shadow of the main structure are primary coloured, in reference to the work of Kandinsky. A close inspection of the stem of the "h" reveals it to resemble the entrance to the school at Dessau.

Labrooy's work reminds us that letterforms are constructions, built from a collections of strokes or geometric parts. His treatment of *Helvetica* (right) as giant windows tells us that type is enlightening. Just as windows grant access to the world beyond, the written word allows access to a world of information. Written language reveals knowledge that may otherwise be concealed.

Chris Labrooy
Bauhaus
2009
www.chrislabrooy.com

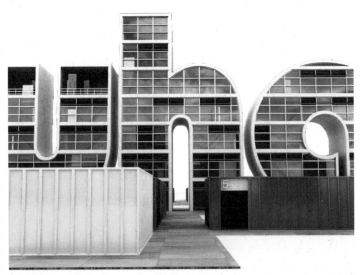

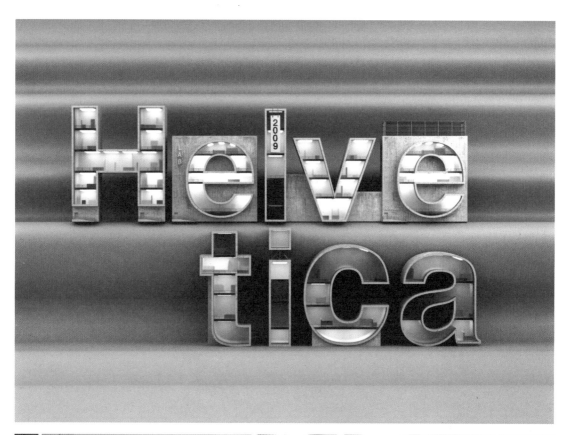

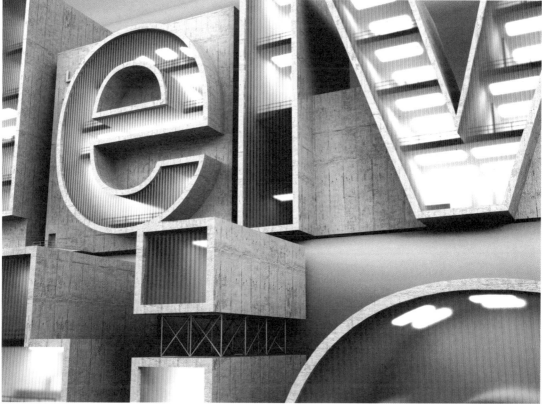

Chris Labrooy
Helvetica
2009
www.chrislabrooy.com

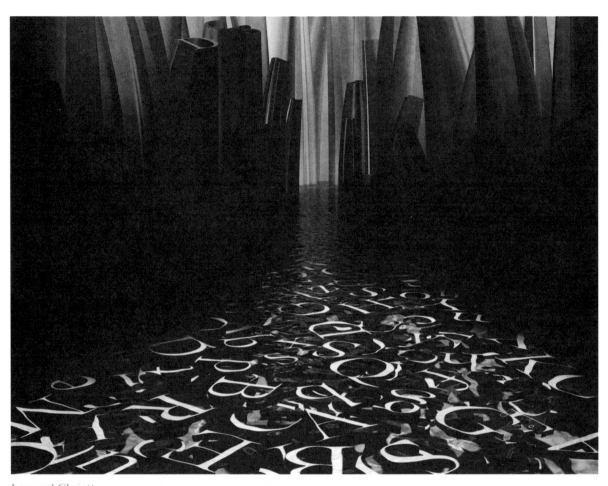

Leonard Clagett
Garamond Gorge
2009
leonardclagett.deviantart.com

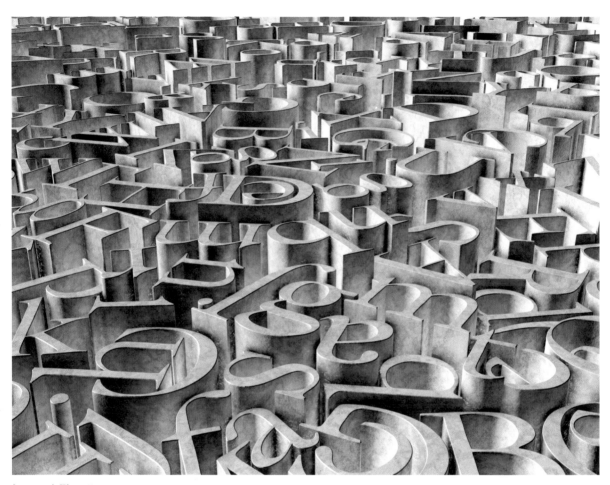

Leonard Clagett
Blue Garamond 7
2009
leonardclagett.deviantart.com

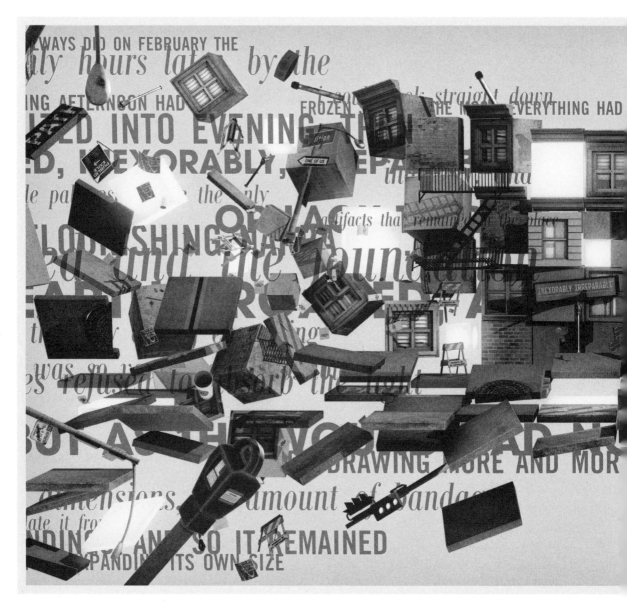

Alex Varanese
Urban Cartography
2009
www.alexvaranese.com

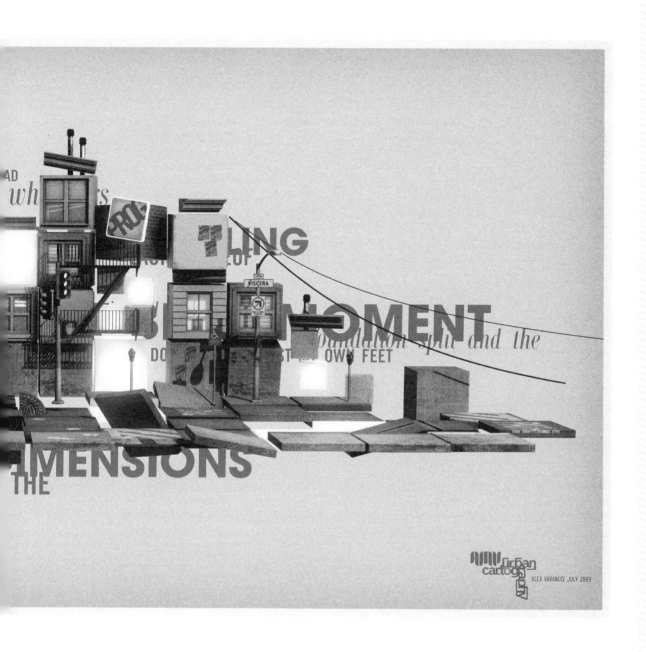

The screen has, in recent decades, overtaken the physical page in the creation and dissemination of type. Televisions, digital billboards, cinema screens and computer monitors are the new media in which audiences encounter text-based information. The computer has become an essential tool for typographers. In these increasingly digital environments, space is treated differently. The screen, though flat, represents virtual, environmental space. We are accustomed to television presenting footage of real, three-dimensional spaces, through which a camera can navigate, and computers representing virtual, explorable environments. The flat screen is imagined as having depth, and everything contained within it therefore has the possibility of volume.

Typographic space, on a screen, is treated as if it contains not one single, flat surface, but many surfaces, all of which may contain pictorial or typographic information. At a simple level, as explored by pioneering digital designers such as April Grieman, type can be layered. Flat surfaces can overlap, with foreground objects obstructing whatever lies behind them. In virtual three-dimensional space, these layers are navigable: audiences (or tracked cameras) may move within them, revealing alternative perspectives. Letters themselves may also have volume. Letterforms are extruded[1], given depth, so that they may be navigated around as if they were tangible objects. These three-dimensional letterforms, and the virtual space they occupy, are perceived as "architectural" and "immersive"[2].

1 Miller, J. Abbott, Dimensional Typography, Princeton Architectural Press, NY, 1996, p. 4.

2 Ibid., p. 2.

The treatment of the typographic space as three-dimensional allows a typographic arrangement to be considered in the same terms as a landscape. In a landscape, visual signifiers of depth are present: objects that are close appear larger than objects further away, and objects that are further away tend to appear higher in our field of vision. In printed type, however, these same visual features signify differently: large or bold text, and text which appears highest on the page, is assumed to be most important. In virtual environments, these typographic standards are replaced with associations and expectations that we commonly reserve for "real", physical space. When an extruded letter is displayed at an unconventional angle, it presents alternative surfaces. These surfaces — the sides, top and bottom of a letter — do not generally appear typographic. The side surfaces of an extruded "N", or "M", for example, are squares or rectangles. This presents practitioners with the opportunity to treat letterforms as building blocks, and to construct landscapes from type, while simultaneously conveying linguistic meaning.

This promotional animation for Nylon (right) immerses the viewer in a three-dimensional typographic space. An urban environment is constructed entirely from extruded type. The surfaces of three-dimensional letterforms become the roads and buildings of a city. The illusion is aided by the presence of a car, which navigates the typographic surfaces, assuring the association with tangible space. This idea can perhaps be originally attributed to Saul and Elaine Bass, whose credit sequence for *Alcoa Premiere* (1961) presents the word "Alcoa", extruded into an arrangement of tall columns. As the camera turns and navigates down the sides of the letters, they are revealed as skyscrapers in a model metropolis.

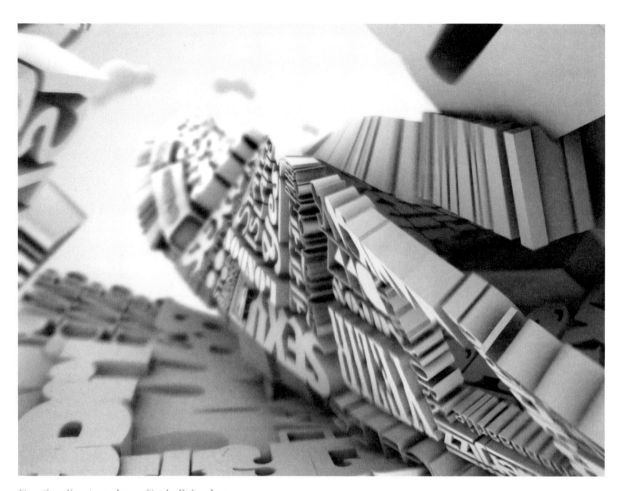

Creative directors: Jason Cook, Brian Lee
Design: Jason Cook, Brian Lee, Brian Castleforte
Animation: Brian Castleforte
Executive Producer: Joe Montalbano
Producer: Jason Kirkham
Sound Design: Scot Lang of BrainCloud
Promo piece/reel for Nylon (www.nylon.la)
2009
www.castleforte.com

Linden Laserna
One Inch Tall
2006
www.superstrangers.com

More common than entirely typographic landscapes is the practice of inserting type into landscapes, to comment on its contents, to give it new meaning, to draw attention to a particular feature, or simply to communicate a personal message to an unknown future audience. Type is often moulded or carved into outdoor spaces, with connotations of ancient inscriptions on cave walls, or messages from lovers carved into tree bark. These messages may be intimate in tone, but are displayed in public places where anyone can read them. They preserve personal sentiment for future viewers, while signalling human presence in otherwise unoccupied spaces.

Cory Fitzpatrick's *Washed Away* (far right) demonstrates how little control man has over nature. Fitzpatrick's moulded "A", in a Garamond typeface, asserts man's presence in a natural landscape, and reflects our tendency to transform the environment to suit our needs. As the tide comes in, the "A" crumbles and dissolves. We are reminded that man-made structures are often fragile, and that natural forces will inevitably reclaim any space that we mark as our own.

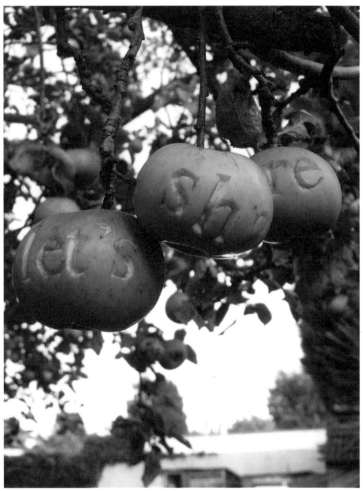

Ethan Park
Let's Share
2008
www.ethanissweet.co.uk

Cory Fitzpatrick
Washed Away
2009
fitzmx6.deviantart.com

It is also possible, of course, to create two-dimensional typographic representations of landscapes. Some may share many of the visual properties of any drawing, painting or other artistic rendering, with the exception that letterforms are used in place of artist's marks.

Cole Johnston's poster for the *Seattle Type Conference* (below) depicts the Seattle skyline. Buildings, constructed of vertical lines of type, appear alongside a column of promotional text. The column of text is grounded in the landscape by the shadow that it casts on the page. The condensed spacing and use of the upper case signifies to the audience that the remaining columns should not be read as text, but should instead be interpreted pictorially.

Images such as *Seattle Type Conference* communicate the identity of a city through a single line silhouette. The city is reduced to its most recognisable feature, with all other detail replaced by type. To a degree, this replicates the experience of reading text. Readers have a tendency to recognise the shape of a whole word. It is therefore the silhouette of the word, not the individual letters within it, that allows us to identify meaning.

Cole Johnston
Seattle Type Conference
2008
www.colejohnston.ca

CITY OF TYPE

TYPECON 2007 BY PAM LEWIS

Where can you find lectures on quantum mechanics, Mexican history and feminine hygiene bags in the same day? Typecon 2007 of course! Hosted by The Society of Typographic Aficionados, this year's conference in Seattle was a huge success. Led by an impressive array of presenters and educators including Robert Bringhurst, Marian Bantjes, Matthew Carter, John Downer, Laura Franz, Shelley Gruendler, Cyrus Highsmith, Akira Kobayashi, Emily Luce, Modern Dog Design, Thomas Phinney, Juliet Shen, Nick Shinn, Veer, and many others, this year's conference did not disappoint.

Typecon 2007 offered participants an eclectic mix of programming with over 25 optional workshops on topics including beginning type design, letterpress postcard printing, hand lettering, visual truetype, Arabic calligraphy, linocut image making, copyright protection, and many more. Educators enjoyed a type and design education forum examining the current status of typographic education and how to take it forward. There was also a screening of Gary Hustwit's highly anticipated documentary *Helvetica*, as well as a return to the 80's with a new wave themed party featuring the infamous type quiz.

The Seattle design community opened their doors to the attendees, hosting numerous events including the School of Visual Concepts' Wayzgoose, reviving a tradition dating back to the seventeenth century where the master printer would host a feast for his apprentices.

One of the main themes of the conference appropriately examined the rise of "grunge" culture in the 1990s and its effect on design. As the hub of all things "grunge", Seattle was at the forefront of this aesthetic, and several presenters including Pete McCracken and the "grandfather of grunge" himself Art Chantry looked back at its rise. Mexican designers Gabriel Martinez Maeve and Leonardo Vasquez Conde, who not only gave an excellent overview of the history of Mexican graphic design, but also brought along some interesting works for the Typecon gallery, were another excellent addition to the conference.

Next year Typecon will be moving across the country to Buffalo, a city full of remarkable architecture, music, food and design. Mark your calendars now! ℭ

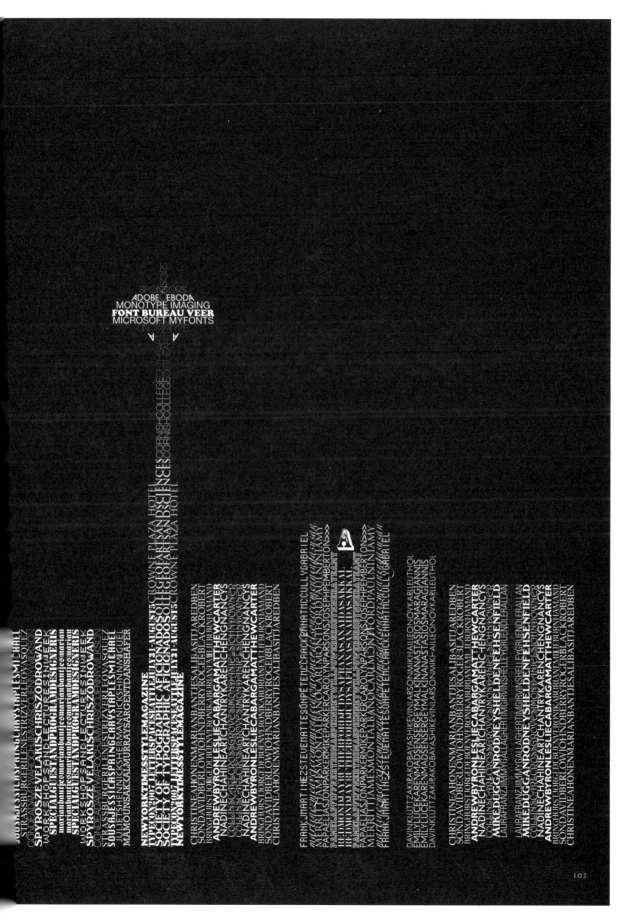

030 / 031

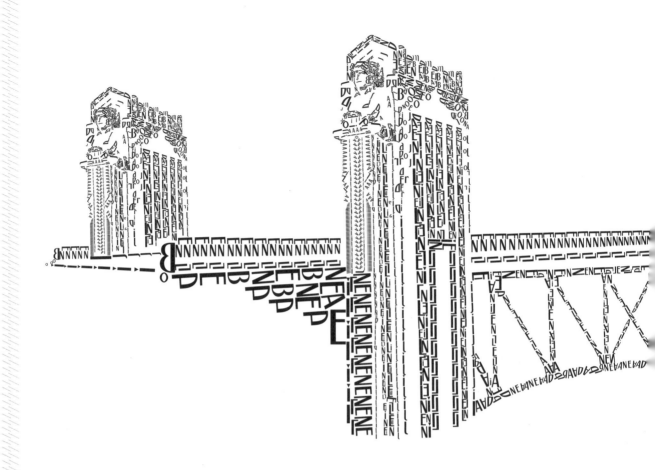

The Cleveland Institute of Art, in collaboration with Veer, asked students to create typographic images of any location in Cleveland. This image by Thomas Nebesar (right) depicts The Blossom Music Center. Nebesar's landscape is constructed from an apparently random collection of letters, containing no recognisable words. The method of letter arrangement distinguishes natural from artificial surfaces: letters, when regularly and tightly aligned represent the man-made building, while loose, chaotic arrangement signifies the natural parts of the scene. Despite the regularity of spacing on the man-made surfaces, individual letterforms are tilted and overlapped, forbidding any linguistic interpretation, preventing even the accidental appearance of a complete word.

In Anna Robertson's representation of Lorain Bridge (above), only an artificial structure is depicted. Complementing the stiffness of Robertson's chosen typeface (P22 Escher), the letters are stacked in orderly columns and rows. The letters are turned on their sides, making linguistic interpretation difficult, and thereby ensuring that the viewer favours the interpretation of the type as architectural building blocks.

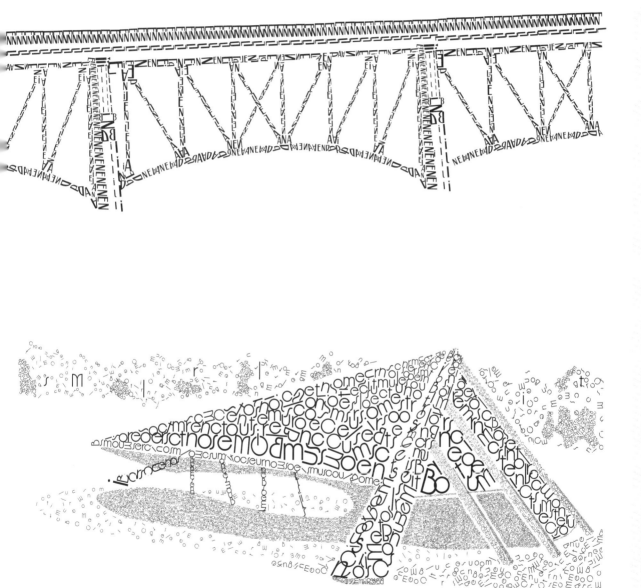

Anna Robertson
Lorain Bridge
2007
www.annarobertsondesign.com

Thomas Nebesar
The Blossom Music Center
2007
www.thomasnebesar.com

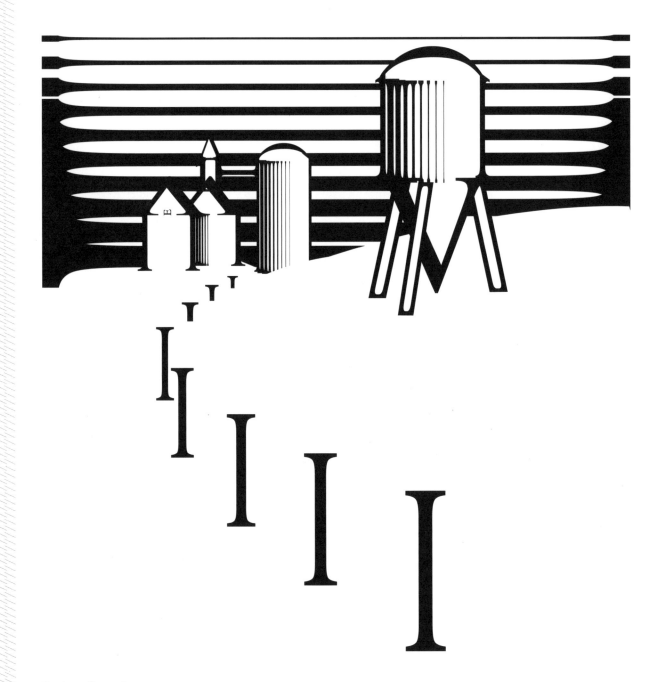

Barbara Brownie
Silo
2009

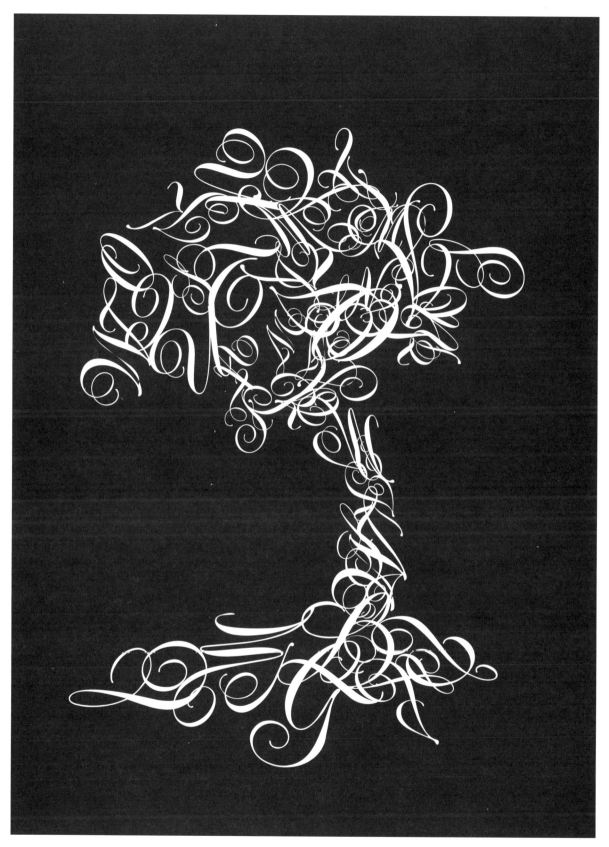

Rafal Fedro
Typotree
2009
www.rafalfedro.com

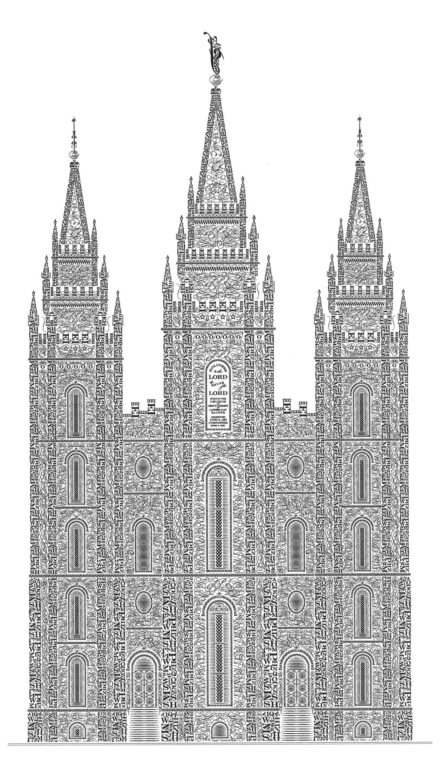

SALT LAKE TEMPLE · SALT LAKE CITY · UNITED STATES

Typefaces: Bickham Script Pro, Engravers MT, Epic

This extraordinary letterpress poster by Cameron Moll (left and above) uses more traditional methods than the examples seen so far. Moll's work illustrates that the typed image is not entirely a digital phenomenon. Breaking from the constraints of the grid, it is possible to create pictorial prints. The letterpress method gives the print physical qualities — variations in surface texture which can be felt when one runs fingertips across the page.

Letterpress is by no means a dying art. Several of the examples in this book utilize traditional letterpress techniques or tools. If a shift has occurred, it has not been towards the discarding of letterpress, but towards a more artistic use. Letterpress printing, which may in the past have been seen as a technical or mechanical process, is now associated with creativity.

Cameron Moll
Salt Lake Letterpress
2008
www.cameronmoll.com

Louise Lawlor
Letters in the Landscape (H)
2008
www.louiselawlor.co.uk

Having become accustomed to the idea of the world as a typographic space, photographers have begun to seek out letters in everyday environments. Embedded in our surroundings, typographers and photographers find forms that bear resemblance to letters, often compiling collections of related forms to create alphabets. Sometimes these forms are temporary—shadows, clouds, momentary alignments of moving objects—preserved by the photograph; others are reliant on the photographer's selective framing. The camera transforms these objects into letters. Alone, they may emerge from the landscape only to the observant eye, but photographed and in the context of other alphabetic forms, the linguistic potential of these objects is revealed.

Although the photographs may be pictorial, with linguistic meaning emerging only to the keen eye, they ultimately perform as type. Once recorded digitally, these photographs can be assigned to the keys on a keyboard, creating pictorial fonts like those discussed in chapter 7.

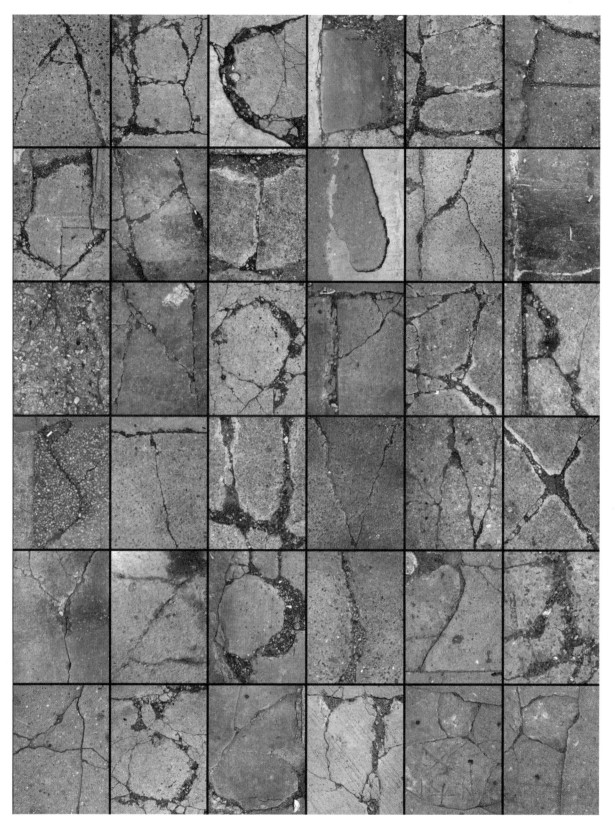

Jason Ramirez
Urban Decay: A Conceptual Typeface
2005
www.behance.net/jasonramirez

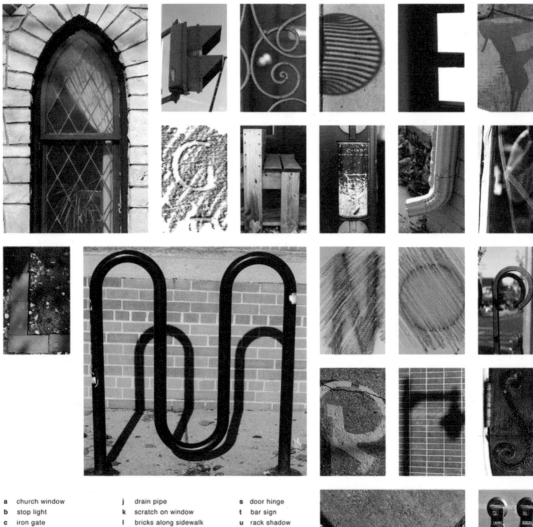

a church window	j drain pipe	s door hinge
b stop light	k scratch on window	t bar sign
c iron gate	l bricks along sidewalk	u rack shadow
d trash can shadow	m bike rack	v glass window
e window frame	n license plate rubbing	w top of a sign
f graffiti on cement	o picture frame rubbing	x cement cracks
g gravestone rubbing	p metal post	y park meters
h bench/seat	q spraypaint	z door handle
i door handle	r light shadow	

Sarah Mick
Found Letterforms
2009
www.sarahmick.com

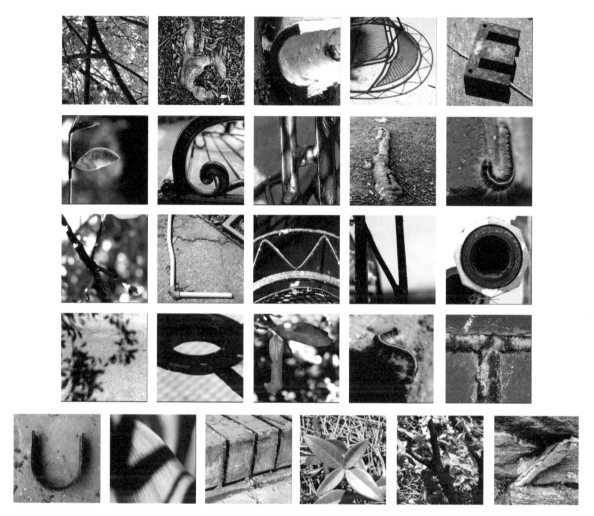

Brittany Scales
Alphabet
2008
www.brittanyscales.com

Emergent letterforms—letters which appear to emerge from the landscape—are not in fact letters. They are merely interpreted as linguistic by the viewer, as a result of human pattern-seeking behaviour. We seek out familiar forms in our surroundings, allowing unfamiliar objects to be transformed into familiar linguistic signs. The emergence of a letterform is, nevertheless, unexpected. It contradicts initial assumptions about the nature of a photographed scene. When, at first glance, a landscape appears pictorial, initial expectations are established of an arrangement of shapes and objects. When letters emerge, viewers are forced to abandon their assumptions, and reassess the scene. Momentarily, objects simulate letterforms, and a paradigm shift occurs: from image to type.

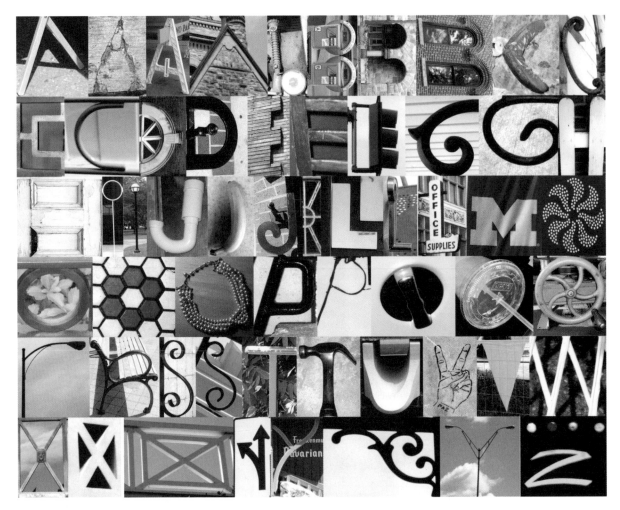

Megan Fizell
Everyday Alphabet
2004
www.tresjoliestudios.com.au

Kalle Hagman
Alphabetical Industrial
2009
www.kallehagman.com

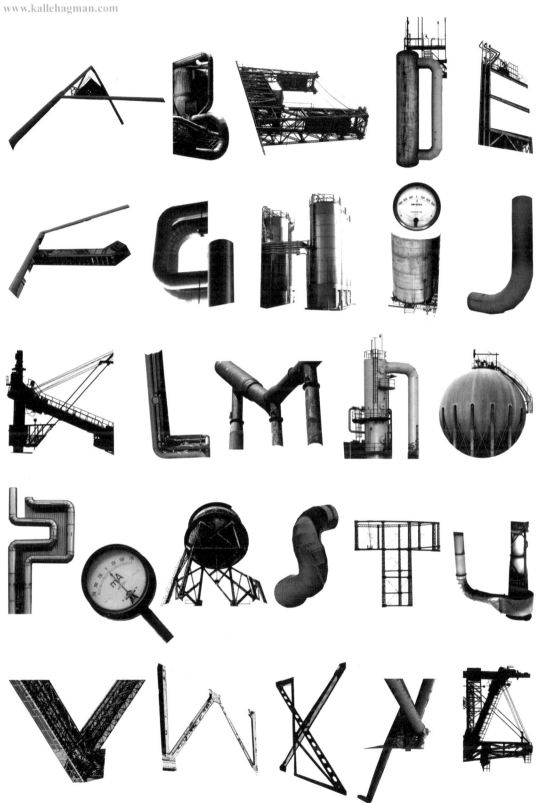

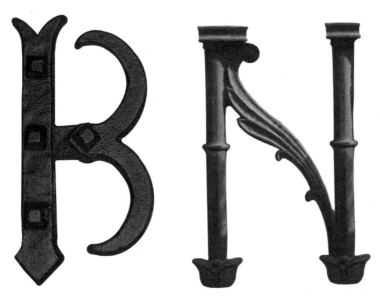

Barbara Brownie
Reclaimed Alphabet (B & N)
2009

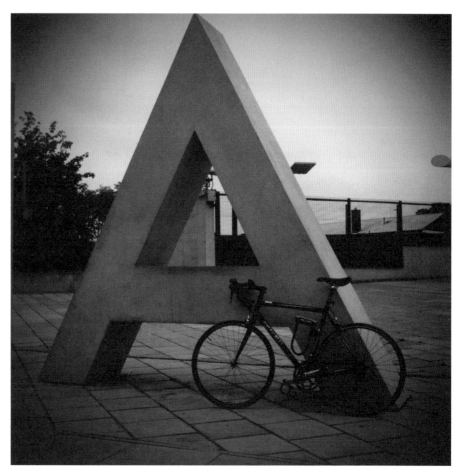

James Bridle
A
2009
shorttermmemoryloss.com

Jim Lind
Urban Alphabet
2009
www.jimlind.com

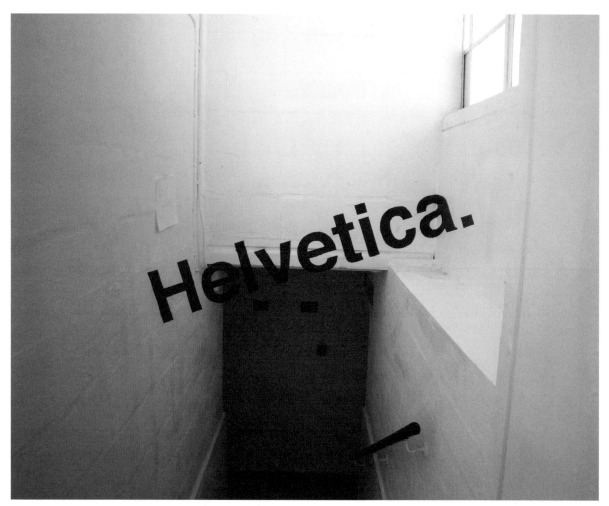

In three-dimensional space, any object may appear to present a different shape depending on its relative position. An elongated shape, for example, may appear to be condensed if viewed from the side. It is possible for a typographic object to appear entirely abstract unless viewed from the correct angle. Charlie Mitchell exploits these features of real-life space to present emergent lettering (above and right).

Mitchell uses the surfaces of a stairwell to present an arrangement of typographic forms. On emerging from the staircase, the viewer is surrounded by almost abstract glyphs. Each letter is skewed and elongated, or sliced into sections, and no discernable message is communicated. On moving away from the stairs, the viewer may observe an entirely different presentation: a complete typographic message. The word "Helvetica" is an illusion. Many of its letters are not in fact whole, but are modularly constructed, and only perceived as whole as their parts appear to align when viewed from an appropriate angle. The letters are not letters, but a carefully planned arrangement of abstract forms.

When the "Helvetica" message emerges from this scene, it appears planar, as if printed on a flat surface. In reality, its parts are spread across a number of different surfaces of variable distances. The letters may only be perceived as whole if the viewer ignores this fact. This has the effect of flattening the space, creating an illusory plane where there is none. There occurs, therefore, two distinct shifts. Firstly, there is a paradigm shift, as a coherent linguistic message emerges from an apparently meaningless collection of shapes. Secondly, there is a shift from three-dimensional to two-dimensional space.

The experience of encountering this emergent type is not dissimilar to the spectacle of theatrical illusion. It is the role of the illusionist to establish expectations about the nature of an object, and then, at the climax of a magic trick, to defy those expectations. As the "Helvetica" message is approached, assumptions are established about the nature of its forms. On climbing or descending the stairs, the viewer finds that those assumptions are challenged, as abstract forms become typographic, or (if the message is viewed on descending the stairs) typographic forms break apart into abstract shapes.

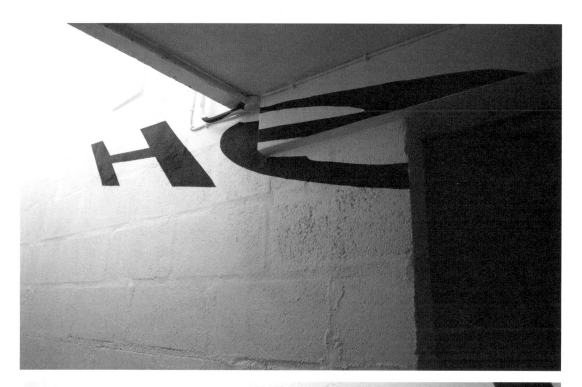

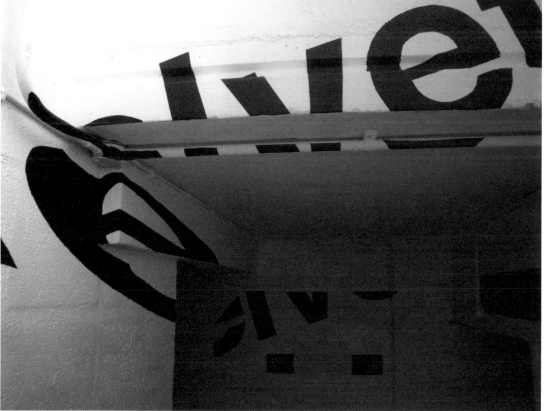

Charlie Mitchell
Helvetica
2009
www.behance.net/CharlieMitchell

Jodie Silsby
Portsmouth Vernacular
2008
www.jodie-silsby.com

Landscapes are commonly simplified to two-dimensional diagrams in the form of maps: graphic representations of landscapes, designed to aid navigation through the represented space, and to define territory. Maps are different from aerial photography in that they are selective[1] — they present only the information that is aligned to their specific use — but whatever the content and purpose of a map, it almost always includes information interpreted as type. Much of this type cannot communicate the required meaning independently of the map, as it works in conjunction with graphical elements. In recent experiments, however, maps have been constructed entirely from type, demonstrating the extent to which the features of a map are recognisable, even when graphical information is removed.

In *Portsmouth Vernacular* (right), Jodie Silsby represents locations through typed speech. In this map, all graphical forms are removed, and typed street names are replaced with records of speech heard at the corresponding locations. The typographic layout, with curved and slanted lines of type, provides enough visual information to suggest the locations of the absent lines.

True to the origins of type, this map focuses on verbal information. Visual indicators of location are replaced with a sound-map of the represented space. Silsby challenges the viewer to locate themselves according to the sense of hearing rather than the sense of sight.

1 Owen, William, and Fawcett-Tang, Roger (ed), Mapping: An Illustrated guide to graphic navigational systems, Rotovision, Switzerland, 2005, p. 11.

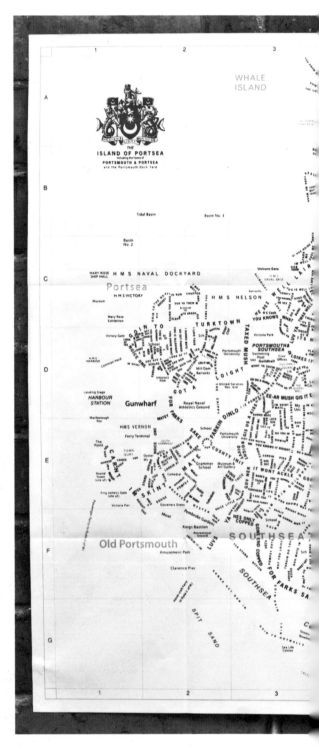

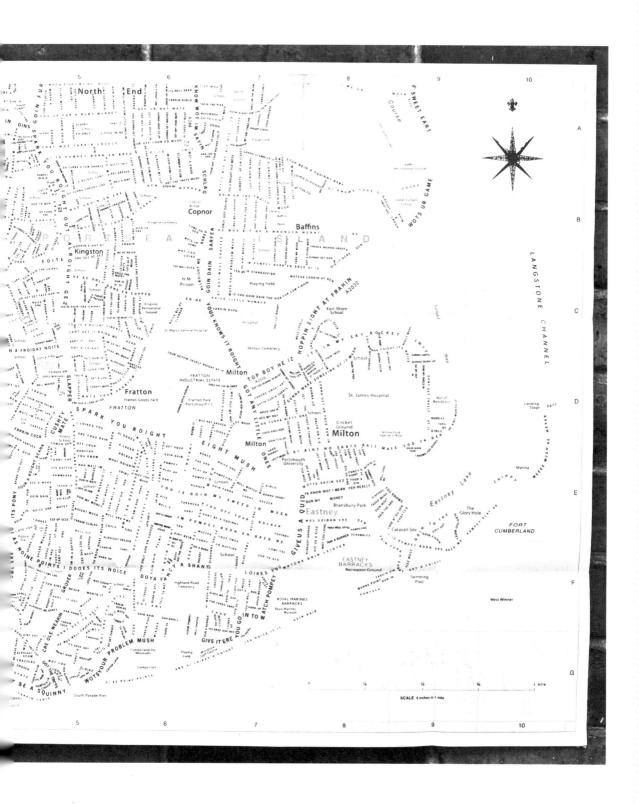

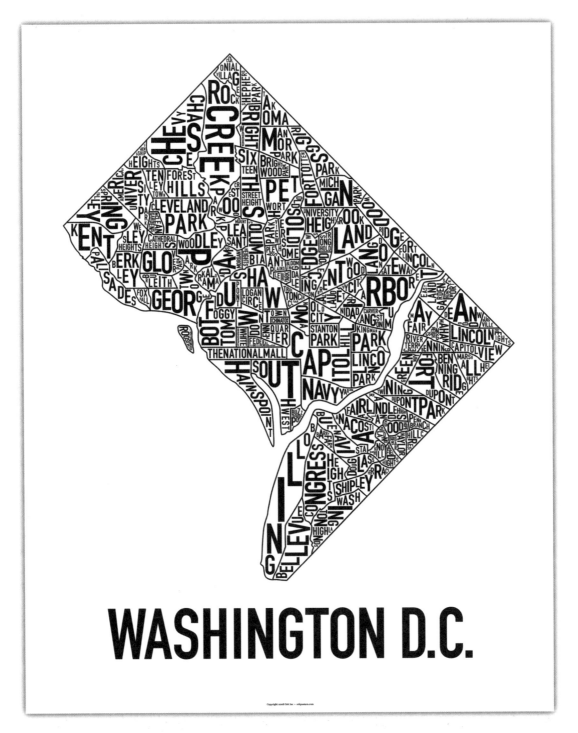

WASHINGTON D.C.

Ork Inc.
City Neighbourhood Posters
2007
www.orkposters.com

Like Silsby's *Portsmouth Vernacular*, Ork Inc.'s series of *City Neighbourhood* posters remove graphical information in favour of type. These maps, featuring various US and Canadian cities, scale and rotate letters, forcing them to fit into the spaces that represent the various neighbourhoods of each city. In the omission of all other graphical and linguistic information, it is implied that the name of each neighbourhood is the most vital piece of information contained within the poster, and yet this information is made almost impossible to receive, rendered almost illegible by the tight spacing, rotation, and inconsistent size of the letters.

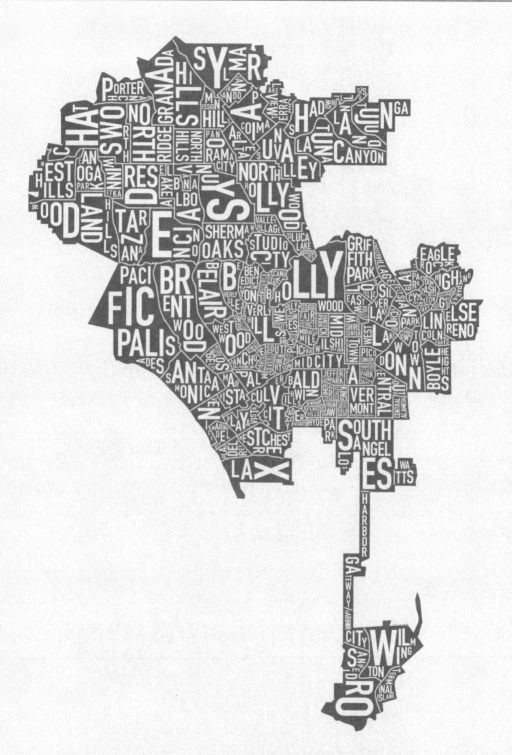

LOS ANGELES

Andrew Thorne
Where Have You Been?
2006
www.19at.co.uk

PeRTh
CLIFF JUMPING
SCOTLAND
EDING-
BURGH
GREAT
BRITAIN
NEWCASTLE
DURHAM
ENGLAND
KINGSTON UPON HULL
THE DEEP
BLACKPOOL ROTHERHAM
SHEFFIELD LINCOLN SKEGGY
WALES
DON
SNOWDON
ABERYSTWYTH
L NOTTINGHAM
LEICESTER
BiRMINGHAM
VILLA PARK
StDAVIDS
FISHGUARD
CARDIGAN
CAMARTHAN
DYFED
MILFORD HAVEN
LITTLE HAVEN
HOUSE
HAVEN
PEMBROKE
HAVERFORDWEST
SWANSEA
BATH CAMBRIDGE
BEDFORD HERTFORD CHELMSFORD
CARDIFF
SEVERN BRIDGE
BRISTOL
READING
WATFORD
FESTIVAL
LoNDOn
GUILDFORD
SWINDON
NEWQUAY
KENT ALDERSHOT
SOUTHAMPTON BRIGHTON
EXETER
STIVES

The world, how I have seen it.
Britain

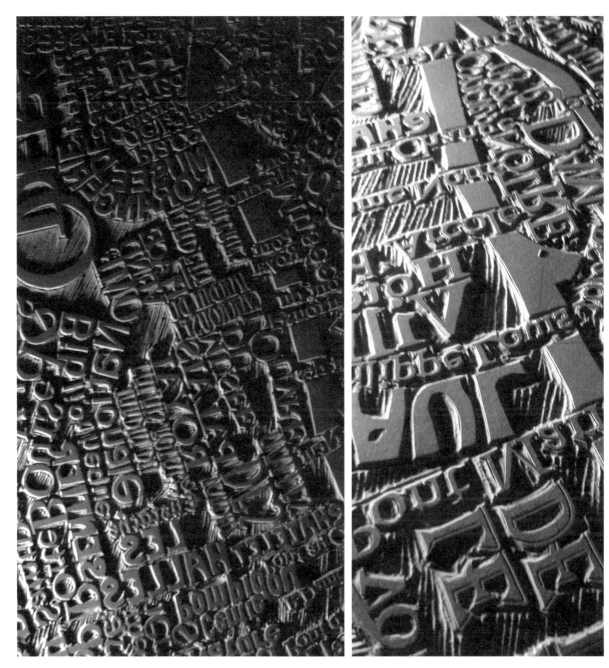

Mark Webber
Paris (linocut)
2009
markandrewwebber.com

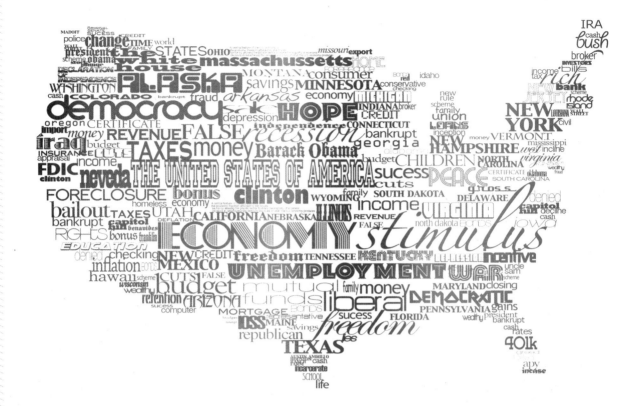

Franklin Benavides
US Typography
2010
behance.net/FranklinBenavides

Charlie Mitchell
London Underground Typography
2009
behance.net/CharlieMitchell

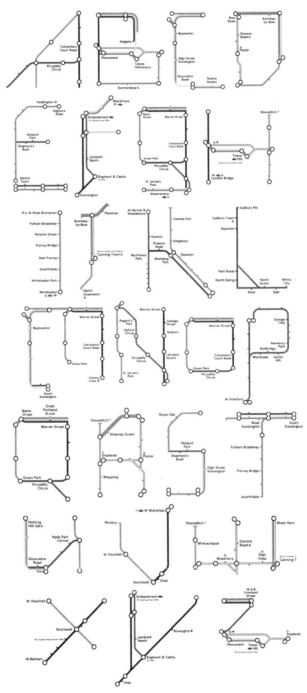

LoNDoN uNDERgRouND

Brian Banton
Never Neutral
2008
www.brianbanton.com

Brian Banton's *Never Neutral* (above and right) represents not one map, but all maps. Rather than describe a specific location, it responds to the nature of the map format. The typographic element of Banton's image is a transcription of a statement by Lucy Fellowes, curator of *The Power of Maps* exhibit held at the Smithsonian in 1993. Fellowes observes that maps frequently present a selective, and therefore biased, interpretation of space. Contour lines, the only visual element present in Banton's image, provide information relating to elevation, but omit information about other geographical or political features.

Banton's work treats letterforms as features in a mapped landscape. The type becomes a mountain range, protruding from the page. Just as a map is not a reliable or complete representation of all aspects of a landscape, this image is not a complete representation of type. The typography is itself selective: the traditional outline of each letter is removed. Instead, the centre of each stroke is assumed to be the highest point, indicated by peaks in contour lines.

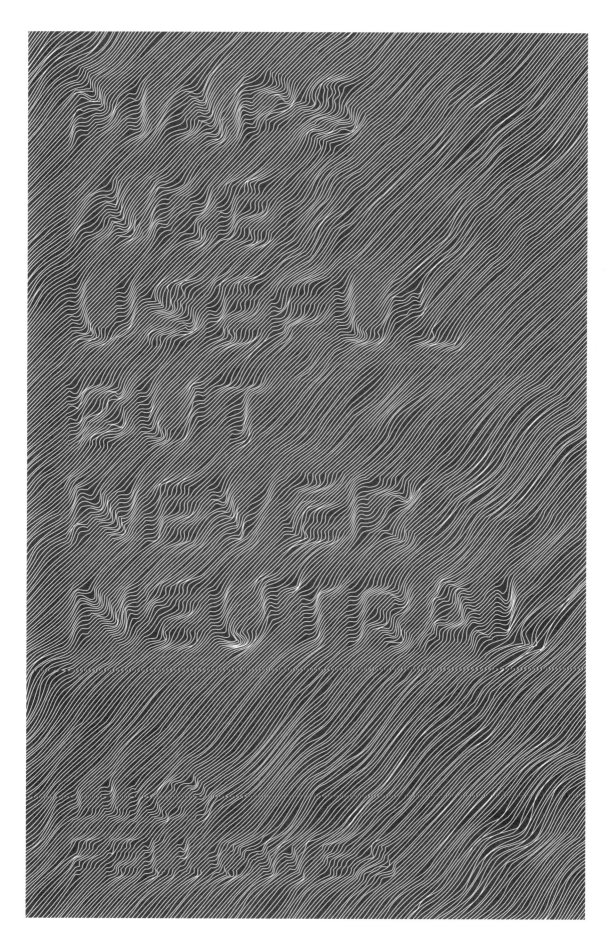

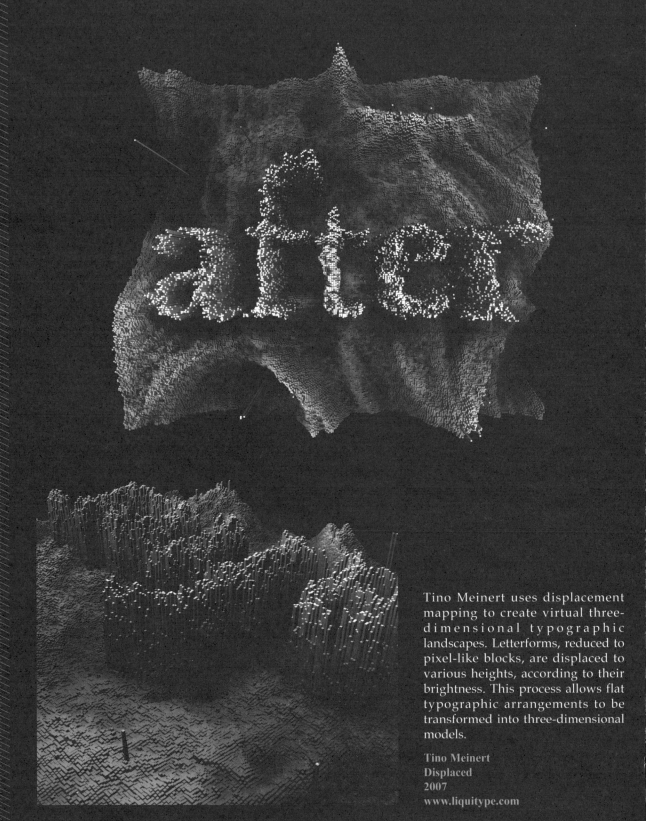

Tino Meinert uses displacement mapping to create virtual three-dimensional typographic landscapes. Letterforms, reduced to pixel-like blocks, are displaced to various heights, according to their brightness. This process allows flat typographic arrangements to be transformed into three-dimensional models.

Tino Meinert
Displaced
2007
www.liquitype.com

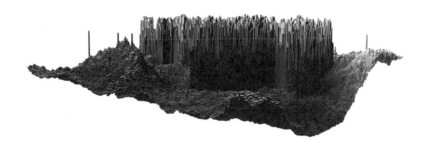

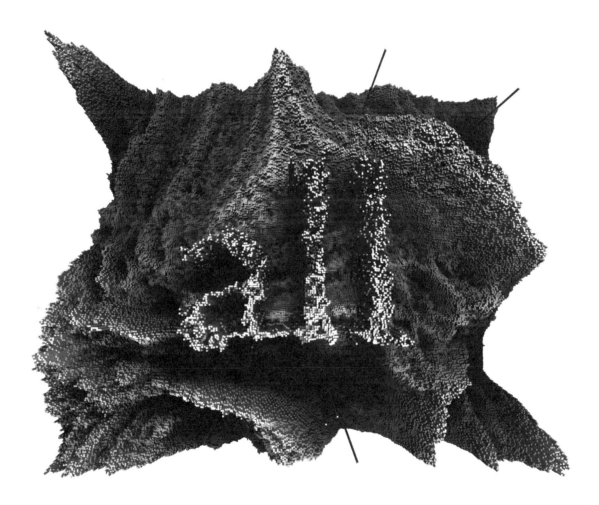

Victoria Tran
Clement Street
2008
www.justalilevil.com

Victoria Tran's *Clement Street* (right) represents textual information found on Clement street, San Francisco. The text is collected from flyers, posters and signs on the street, and original typefaces and composition are retained from these sources. The type, in this new context, no longer serves the purpose of labelling its environment. Removed from the landscape, it becomes a representative collage. Much like a map, this arrangement identifies locations and establishments on the street, but the linguistic information is so dense that it becomes too much to handle linguistically. The type, recognised as having no practical use outside of its original context, is treated as texture instead.

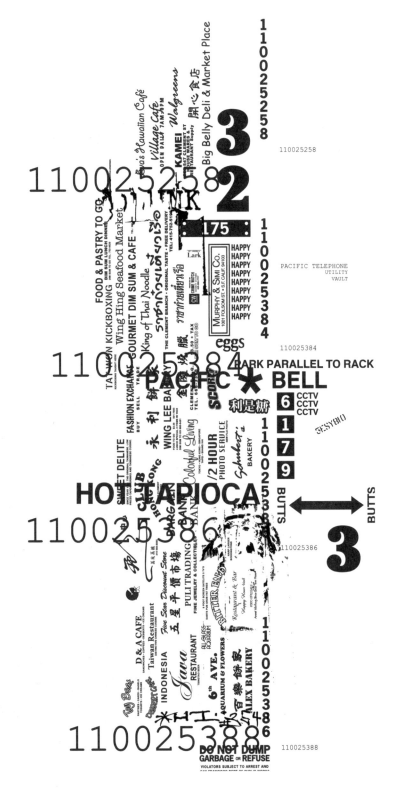

Ryon Nishimori
Directions Poster
2009
www.ryanwestwod.com

Directions by Ryon Nishimori (right) is representative of the experience of moving through a landscape. The presence of multiple surfaces is suggested by skewed letterforms, some apparently resting on horizontal ground, and others pasted onto a vertical backdrop. Some letters are extruded, implying the presence of three-dimensional space, while others are titled or rotated, forcing the viewer to investigate the scene from different angles. Although this arrangement has pictorial features, the type must be read in order to recognise the meaning of the image. Each typographic label describes objects and events encountered while on a journey. As linguistic narrative, the type can be read as directions — equivalent to a map. As image, this piece is an explorable space, decorated with typographic forms.

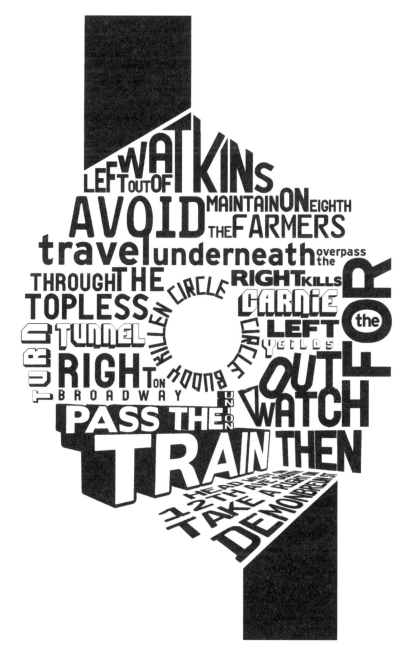

3 Typographic Portraits

Typographic portraits owe their history to the Typewriter and ASCII art that preceded computer graphics capabilities. With typewriters, and later, word processing software, artists directly typed images using and combination of the printable characters available on the keyboard (though more recently, ASCII Art generators have become available, allowing artists to bypass the typing process altogether). ASCII art was initially necessitated by the limited graphics capability of early desktop computers, but later found popularity amid trends for nostalgia. More recently, graphics software have allowed typographic designers to manipulate type in ways that were not previously possible. Nevertheless, many of the underlying principles of ASCII art remain in contemporary typographic portraits. Fuller characters (such as "O") are still used to define areas of highlight, while narrower characters, which can be more densely packed, define areas of shadow. As is often the case in design, a trend initially inspired by the limitations of technology, has been embraced in hindsight, and improved while managing to maintain the appeal of its predecessors.

Typographic portraits tend to use type in two distinct ways. The first method involves using type as surface. Type indicates the contours of the face, with densely spaced or layered type representing areas of shadow, and sparser type allowing blank space to suggest highlights. This is the method used by Irene Shih in her *Type Face* and Stefan Holodnick in his *E. E. Cummings Layout* (both overleaf). In the second method, the text is typed over a photograph, becoming a series of frames through which the image is viewed. Here, the type itself is not surface, it reveals surface that is already present within the photograph. The parts of the photo which lie outside of the type are removed, turning figure into ground.

It is often the case with these portraits that the type has linguistic meaning that is pertinent to the subject. Unlike in ASCII Art, where characters are chosen purely for their pictorial values, contemporary typographic portraits are often constructed from words which relate to the character of the subject, or phrases that represent his/her achievements. In the case of self-portraits, or when the subject is unknown, the type may describe emotional characteristics. Portraits of celebrated personalities describe, pictorially, the appearance of the subject, and, linguistically, the reasons for his or her cultural or political importance.

Barbara Brownie
Sarah
2009

my sweet old etcetera after all white horses are in
aunt lucy during the recent
dying is fine)but Death little who walking beside me, my
Why don't be silly the scarcely the somewhat city
deed: money can't do wiggles in considerable twilight
?o (never dead every enormous piece
baby is here h a sense which a suddenly unsaid
i an with his sen must cal

f you and i awake

be unto love as rain the and dying terrible the
is unto colour;(create)this alive individual..a wise
me gradually(or as moving ALIVE
really(or as
ills even the a Death
of clove
of success than most
break-chain va

simply me each how
my trembling where my when
still invisible

songs contain
toward me the crying
if i guessable mirrors original
heart,because at beauty plaining)
when you've
intell gence to good
—always think a cummin hevers of a lear
gne like a sun alone
must more than agree)
sometimes,to m and feel—
earth;body love re in we;
for you rile we we above
we were each other Public
and under all possible worlds) in love.
disappear undeath
life in your pants
lighth's th dreams are frail)
breath
sizeless truth of a dream

smiling
gradual whose sleep is the sky and the earth and the sea.
slips
singu ngdom the keen primeval silence of your hair

(sle you
ile some
th

—let the world say "his most wise music stole
nothing from death"—

you on
(who are so perfectly alive)my shame:
lady through whose profound fragi
the sweet small clumsy feet pri

into the ragged meadow of l.

cummings's innovative and contro
verse places him among the most popular and widely anthol
poets of the twentieth century. while linked early in
career with the Modernist movement, he wrote poems with

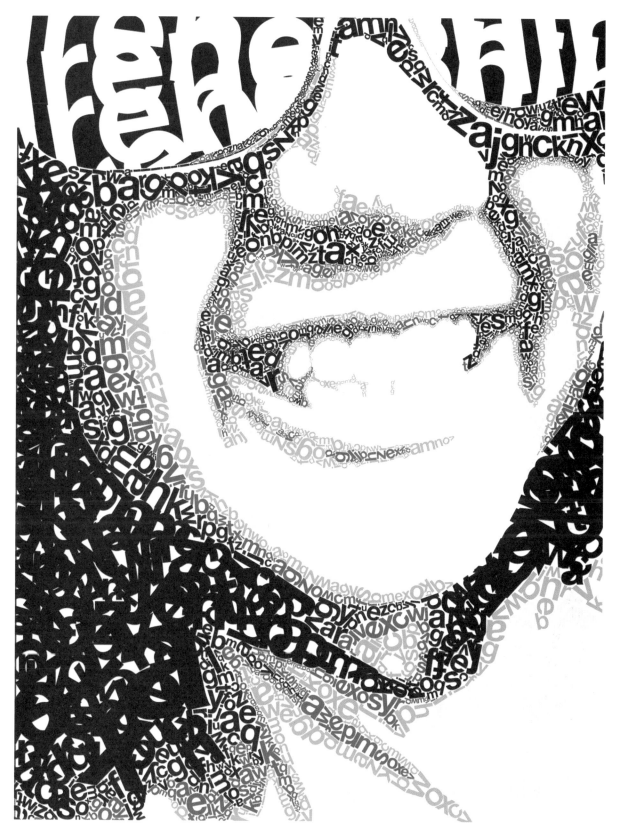

Yen-Hui (Irene) Shih
Type Face
2009
flickr.com/ireneshih

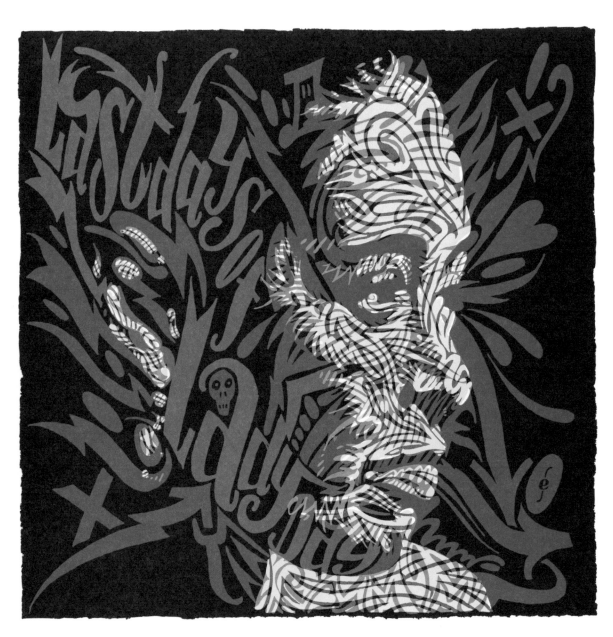

Enkeling
Last Days of Lady Day
2007
www.enkeling.nl

Gui Borchert
Poster for the "Artists for
Obama" series
2008
www.guiborchert.com

Barack Obama's 2008 US election victory was due in no small part to his skill as an orator. Obama wooed crowds with emotive language, and his aims were summed up in a single, evocative word, "change". In the lead-up to the election, numerous portraits appeared depicting Obama alongside his key election slogans, "hope", "change", and "yes we can". Some, including portraits by Gui Borchert (right), Jeff Clark and Troy Bedingfield (overleaf), incorporate these slogans into the image of Obama, signalling that these promises are deeply embedded within Obama's personal aspirations: that Obama made these promises not just to the electorate, but also to himself.

Central to the election was the issue of race. One cannot fail to acknowledge that two of these portraits (overleaf) are constructed from a combination of black and white, collaborating in the construction of the image.

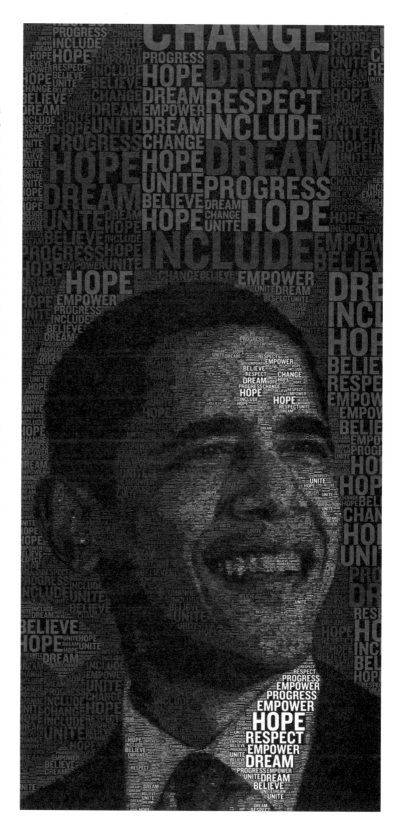

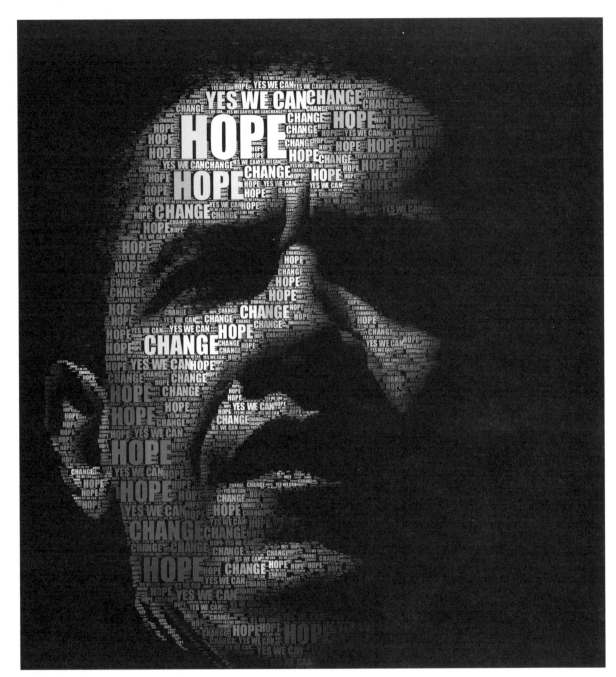

Jeff Clark
Obama: Change, Hope, Yes We Can
2008
neoformix.com

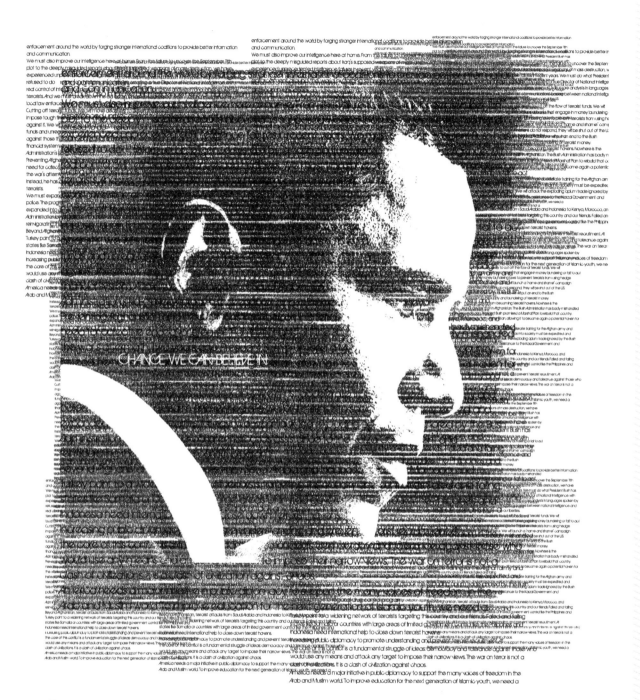

Troy Bedingfield
Presidential Candidate in Type
2008
destroysdesign.com

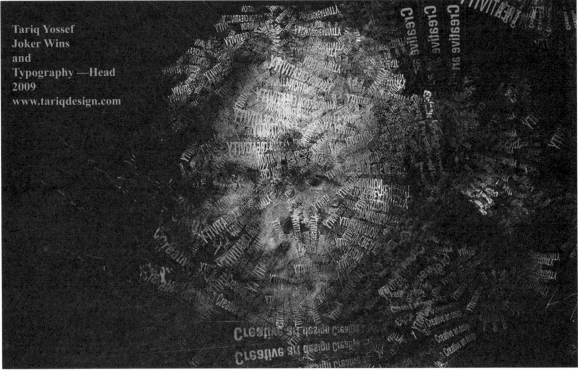

Tariq Yossef
Joker Wins
and
Typography —Head
2009
www.tariqdesign.com

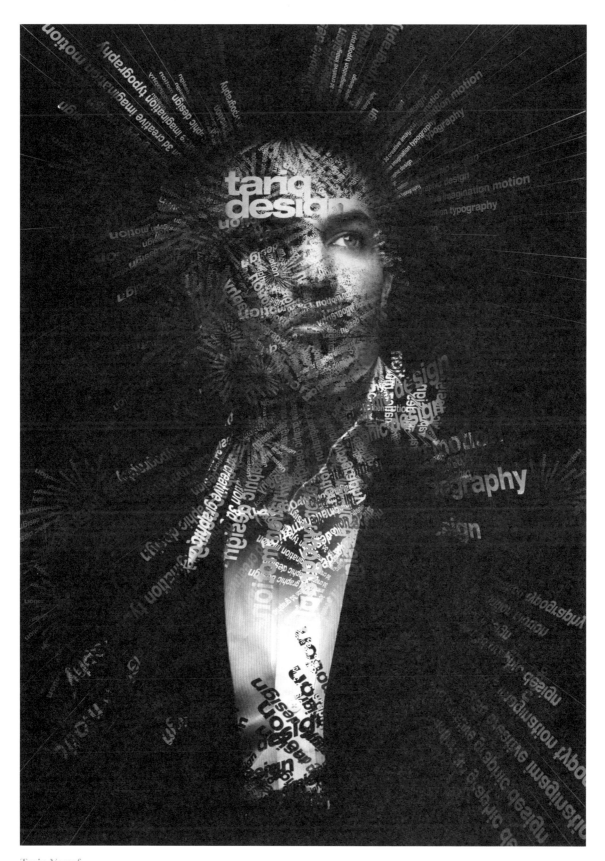

Tariq Yossef
After 10PM
2009
www.tariqdesign.com

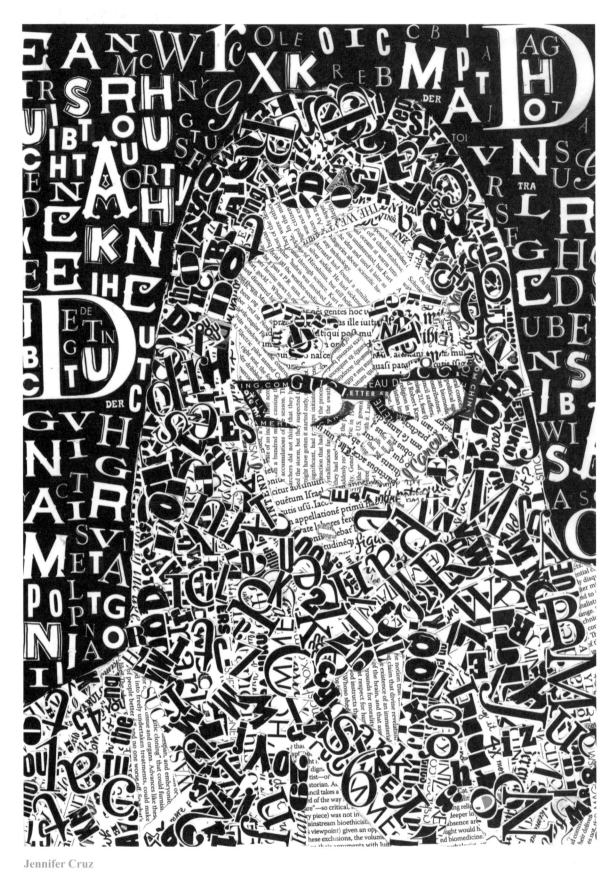

Jennifer Cruz
Type Portrait
2009
www.behance.net/JenniferCruz

Julie Mattke
Soul of the Typographer
2009
dzignjulz.blogspot.com

Jennifer Cruz's *Type Portrait* (left) is not directly typed, but "cut-up", constructed from "found" type rather than created directly with the use of a keyboard. Here, type is stolen — removed from its original context. This recontextualisation of type has origins in the works of OULIPO, a 1960s group of French poststructuralists. OULIPO constructed new texts from old, slicing up and rearranging existing texts by other authors to form new narratives. Removed from their original contexts, these extracts took on new meaning. In this portrait, a similar event occurs. Old text is given new, pictorial meaning. It's original authors have been forced to sacrifice control of their work, as in its new setting, it no longer operates as linguistic narrative.

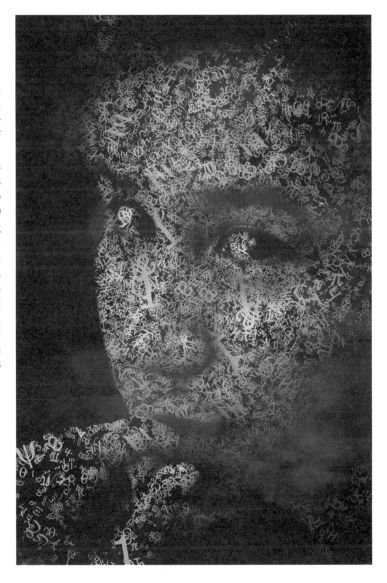

Nick Konings
Biographical Illusion
2009
www.linkedin.com/in/nickkon-
ings
(brushes by Obsidian Dawn)
obsidiandawn.com

A number of typographic images, including Nick Konings' *Biographical Illusion* (above) and Julie Mattke's *Soul of the Typographer* (previous page), are "painted" using typographic brushes. Photoshop allows the creation of brushes from a selected area of a canvas, making no distinction between pictorial and typographic selections. Linguistic signs, either written or typed, are thereby interpreted by Photoshop as being no different to pictorial information. The presence of type becomes almost incidental. After the initial process of defining the brush, the process of painting the portrait is identical whether the brush is typographic, abstract or pictorial.

A more complex painting process is represented by *Old Boy* (right). Here, type has been automated, appearing in varying size, rotation and position in reflection of the position, speed and direction of the mouse. This piece reflects the increase in generated imagery, in which subjects are generated by purpose-built software rather than drawn or painted. These images are not so much designed as automated.

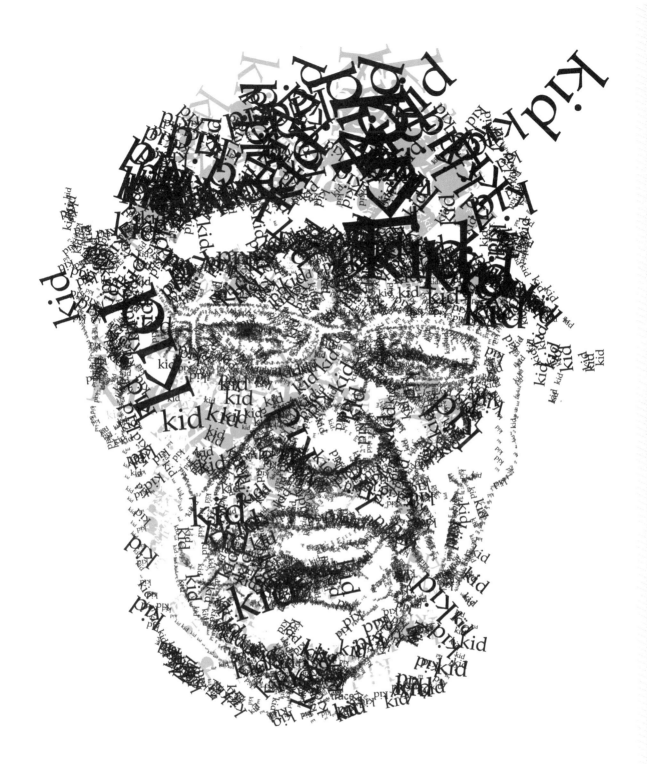

Nick Konings
Old Boy
2007

In typographic portraits, type may operate as contour or as surface. As surface, type tends to be kept small and is often layered. As contour, individual strokes are used to define the silhouette and features of the face, usually requiring the use of large letterforms. With fewer, larger letterforms, the portrait becomes more abstract, and each letterform plays a more significant role in the construction of the face. The variety of typographic forms in the standard Roman character set offers designers a palette to suit any possible face, with varying stroke width, curved and straight strokes. Each letter must be carefully, purposefully selected for its visual similarity to an area of the portrait, as it is in Eliana Becerra's *Sintesis* (overleaf) and David Yenga's *Autorretrato Tipografico* (right). Yenga relies on curved typographic forms to indicate soft coils of hair, while the brows are suggested by the stiff stems of "l" and "f".

Barbara Brownie
Josie Bei
Self-portrait in Type
2009

David Yenga
Heart Industry
Autorretrato Tipografico
2009
flickr.com/photos/heartindustry

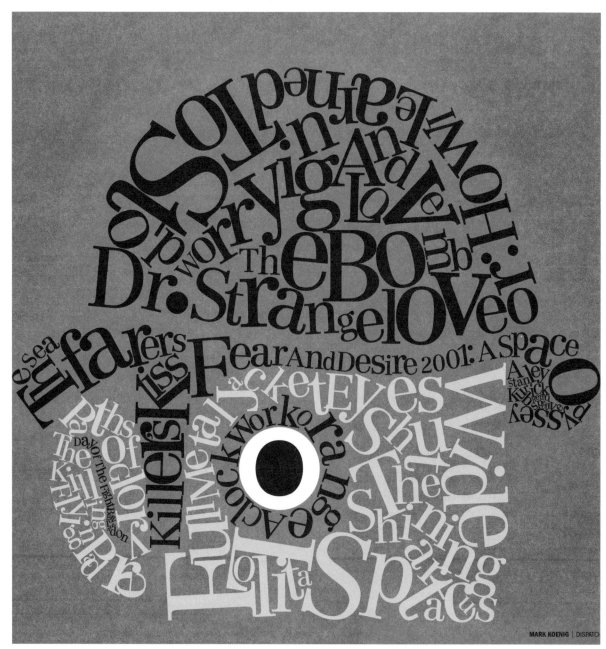

Mark Koenig
Kubrick
2008
mwkoenig.daportfolio.com

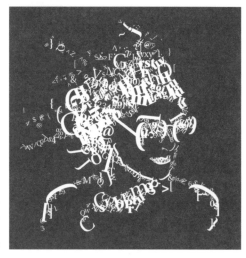

Kiki Tohme
Type
2008
www.kikitohme.com.br

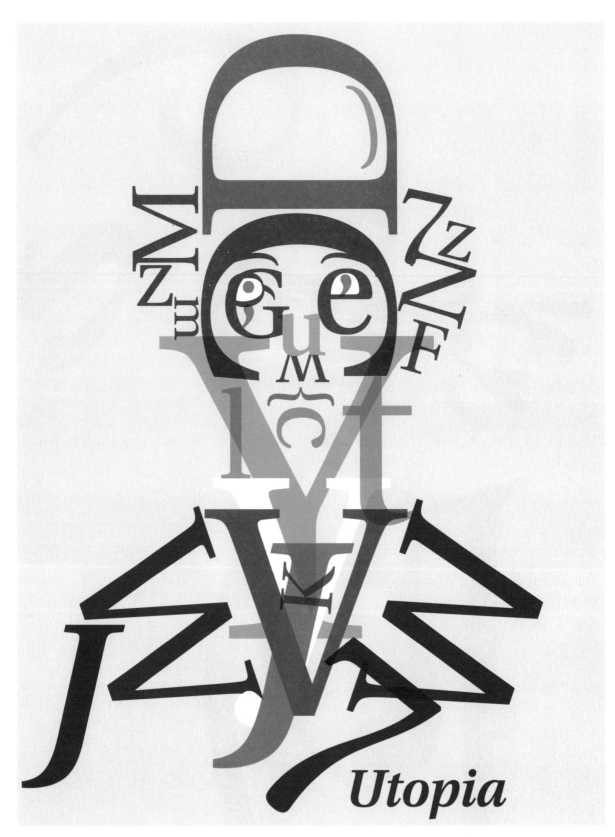

Paula K. Wirth
Charlie Chaplain was a Real
Character
2007
www.inkvision.com/portfolio

Maris Hartmanis
Awake
2009
www.behance.net/hartmanis

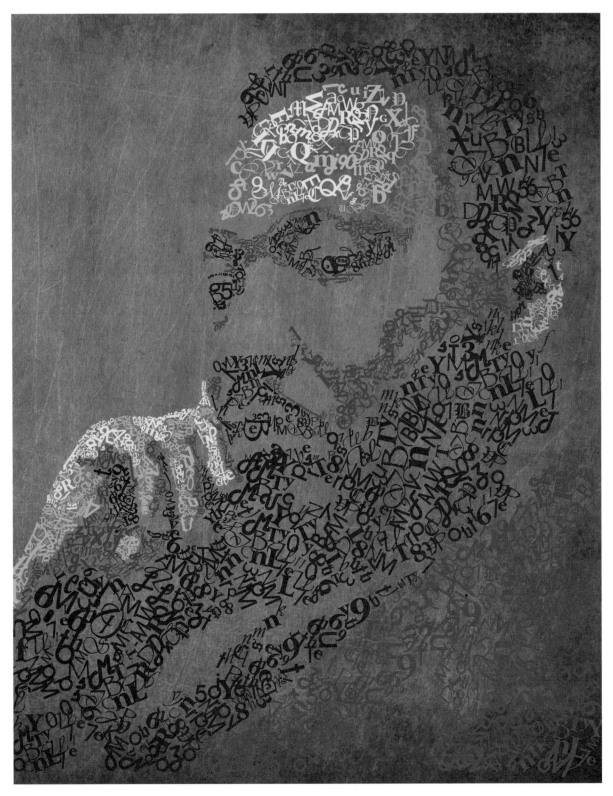

Moses Y. Pranata
Freedom
2008
www.mosespranata.com

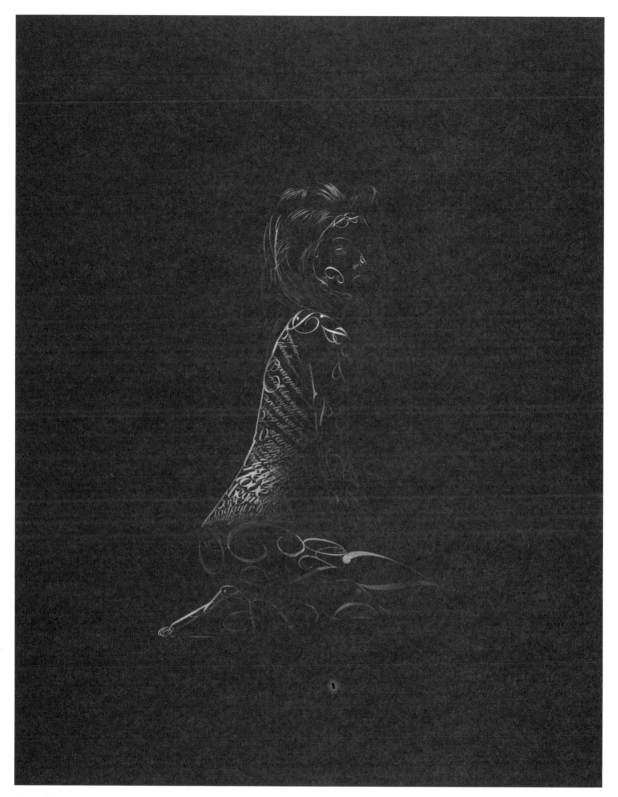

Blake Fawley
Afterwards
2009
www.blakefawley.com

Richard Sykes
Head Sectional Tall
2009
yorik220.carbonmade.com

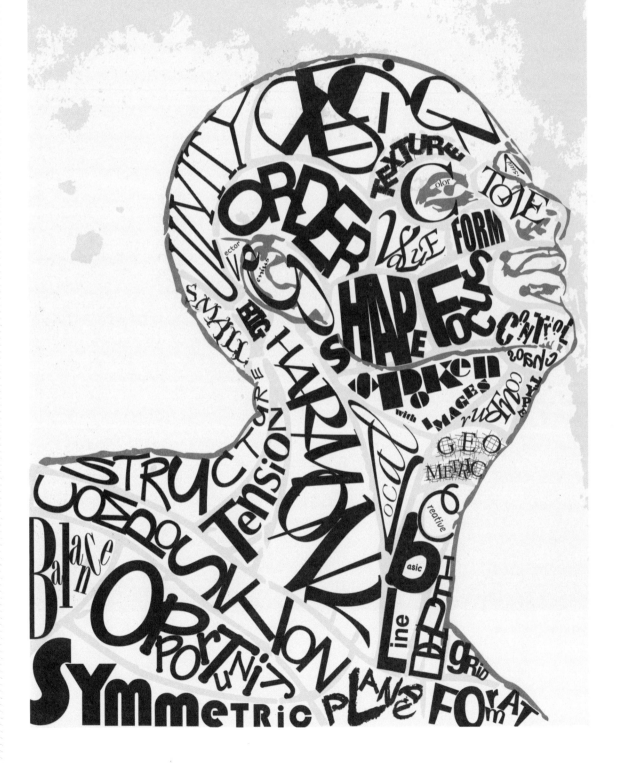

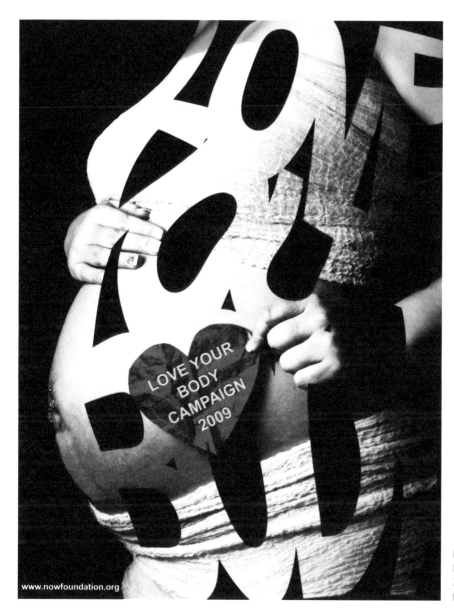

www.nowfoundation.org

LOVE YOUR BODY CAMPAIGN 2009

Harshal Desai
Love Your Body
2008
harshaldesigns.blogspot.com

Portraits may of course be anonymous, representing a personality type rather than a specific individual. Harshal Desai's promotional image for the *Love Your Body* campaign (above) is representative of any pregnant female. The curves of letterforms are softly distorted to match the curves of the curved stomach, while a bold typeface reflects the weight of a pregnant body.

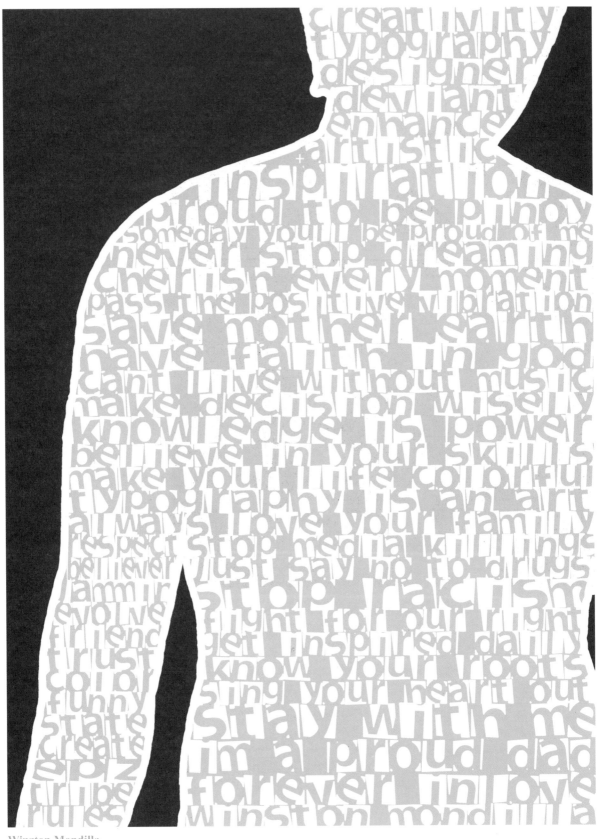

Winzton Mondilla
Typography Inside Me
2009
wmondilla.deviantart.com

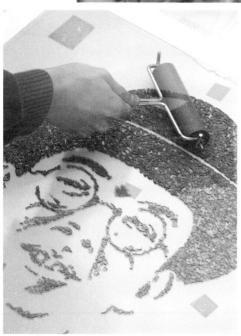

Daniel Schmid
Portrait of Jan Tschichold
2009
www.typefaces.ch

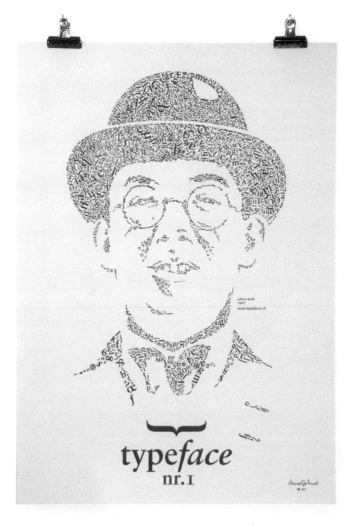

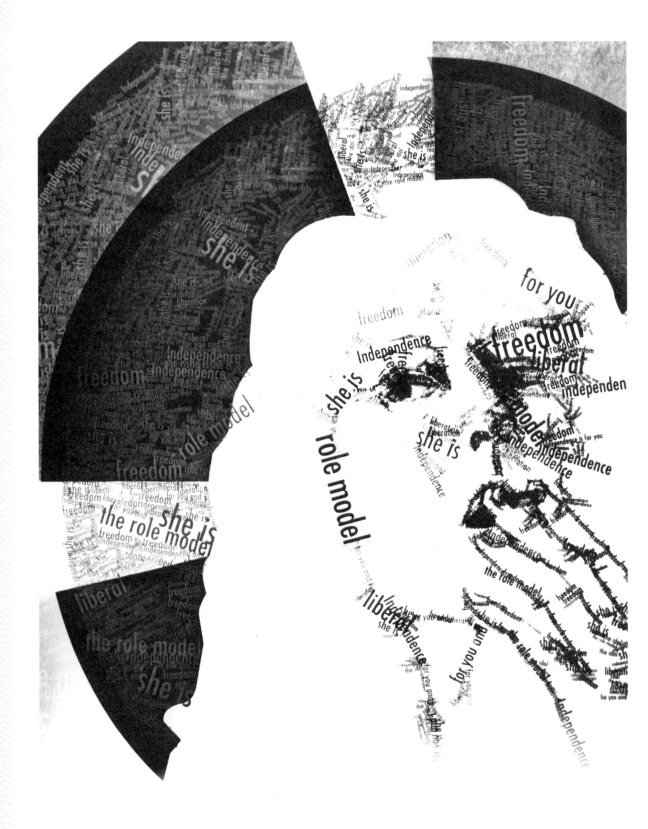

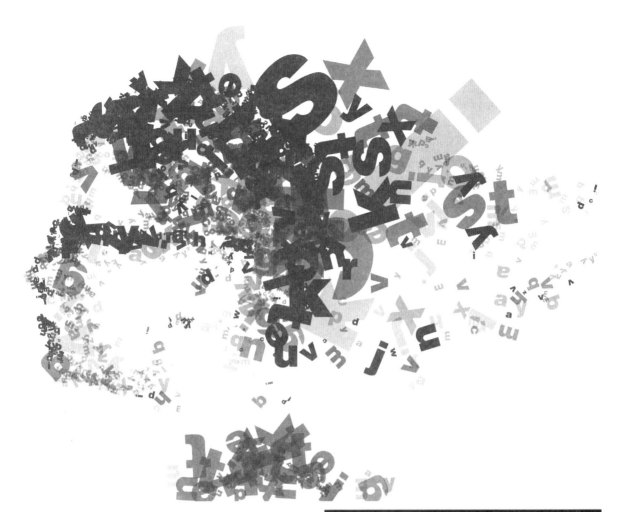

Dominik Wisniewski
Typo Self-Portrait
2008
www.d-wis.com

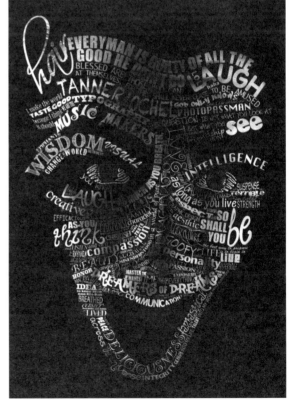

Tanner Ochel
As You Type, So Shall You Be
2009
www.tannerochel.com

4 Emoticons

The ultimate typed image, emoticons can be created entirely with the use of the keyboard, requiring no additional manipulation with graphics software. The ubiquitous "smiley" first appeared in the 1980s[1] in order to aid expressiveness to message-board posts. On early online message boards, formatting options were limited, and users had only one default font option. In order to effectively communicate the tone of a message, users developed ways of communicating their emotions through small combinations of typographic characters. Emoticons became projections of "human values"[2] in the non-human world of computing.

Emoticons exist within typed language, but not within spoken language. There is no direct linguistic equivalent to a smiley, only an emotional equivalent. Their use is perhaps indicative of a deficiency in our language. There is no short, sharp way of expressing emotions that is not reliant on tone of voice or visual cues such as facial expressions. The elaborate language of poetics may elegantly describe a feeling, but would be over-extravagant in an internet chat room.

Now firmly established within typed language, emoticons are subject to the same treatment as other languages. At a basic level, they appear in a variety of fonts, with each font bringing its own connotations, granting subtle variety to the emotions portrayed in each depicted face. As demonstrated here (right), different typefaces endow the smiley with different personalities, from cheeky, to bemused, to maniacal.

Emoticons also form the subject of more complex typographic experimentation. Allison Wilton features emoticons in her artist's book (overleaf). In Wilton's work, emoticons are rotated and layered. As with standard type in other typographic experiments, removed from their usual context these emoticons lose their original meaning, becoming abstract shapes and patterns.

1 Azuma, Junichi, and Ebner, Martin, 'A Stylistic analysis of Graphic Emoticons', Proceedings of the World Conference on Educational Media, Hypermedia and Telecommunications, 2008, p. 972-977, p. 972.

2 DiSalvo, Carl, and Gemperle, Francine, From Seduction to Fulfillment: The Use of Anthropomorphic Form in Design, 2003. http://anthropomorphism.org/pdf/Seduction.pdf,

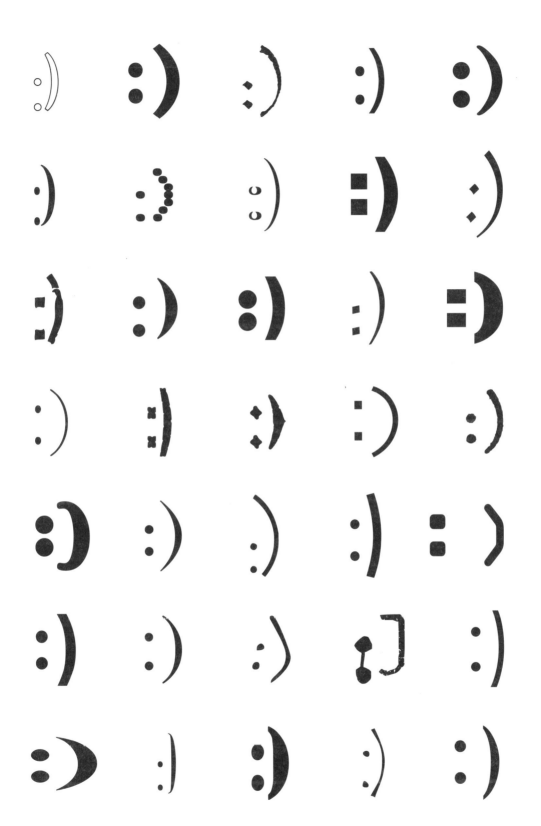

Allison Wilton
Emoticons
2008
www.allisonwilton.com

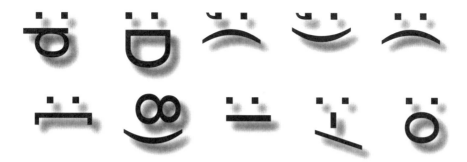

Emoticons are used to reflect our state of mind. They communicate to others our emotions when they cannot be witnessed first-hand. When they appear on the screen they are a reflection of ourselves at that moment. In that respect, emoticons become temporary avatars. They are our on-screen identity, or at least the part of our identity that we wish to communicate to others.

In the moment of the appearance of an emoticon, an "object-subject interchangeability"[3] occurs. A bond is created between the inanimate typographic forms on the screen and the person who typed them. The forms on the screen may be inanimate, but they represent a cognisant being. Each small collection of juxtaposed punctuation is imagined as able to experience complex, abstract emotions.

Emoticons depict only the face: the most expressive part of the body. It is often the case in portraits that the ratio of face to body influences how a subject is perceived[4]. When the face is dominant, the emphasis is on personality, but when the whole body is shown, attention is given to physical attributes. Through the complete absence of a body, emoticons communicate only emotion, not physical appearance. Emoticons are therefore capable of representing any individual, regardless of appearance. They, in theory, are universally applicable. It could be argued, therefore, that emoticons are not in fact images. They do not represent that which is seen, only that which is felt. They may have evolved from images, but so have many other written or typed characters. It is necessary to note, however, that there are cultural variations. The Japanese "smiley" has a flat mouth (an underscore), in reflection of the Japanese tradition that teeth should be concealed when smiling. There is, therefore, a small but significant element of the visual represented in these signs: if not enough to signify an individual, at least enough to differentiate between different gestural traditions.

3 DiSalvo, Carl, and Gemperle, Francine, From Seduction to Fulfillment: The Use of Anthropomorphic Form in Design, 2003. http://anthropomorphism.org/pdf/Seduction.pdf,

4 Lidwell, William, Holden, Kritina, and Butler, Jill, Universal Principles of Design, Rockport, Mass., 2003, p. 72.

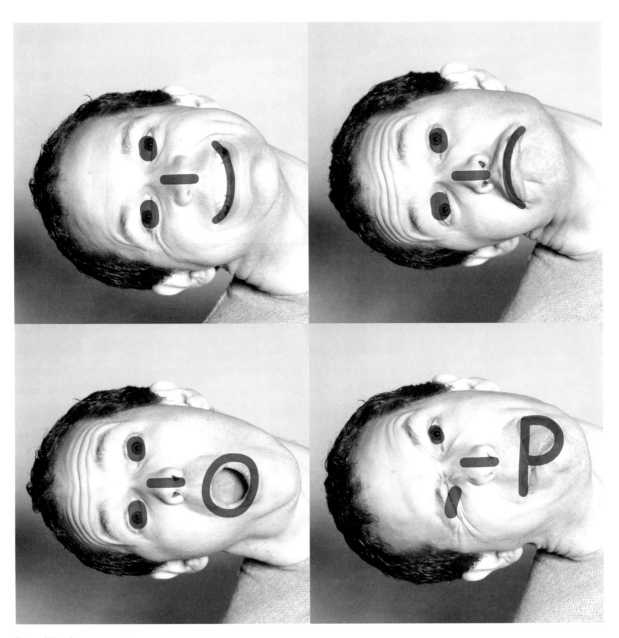

Dave Wood
Emoticons
2007
www.davewoodphotography.com

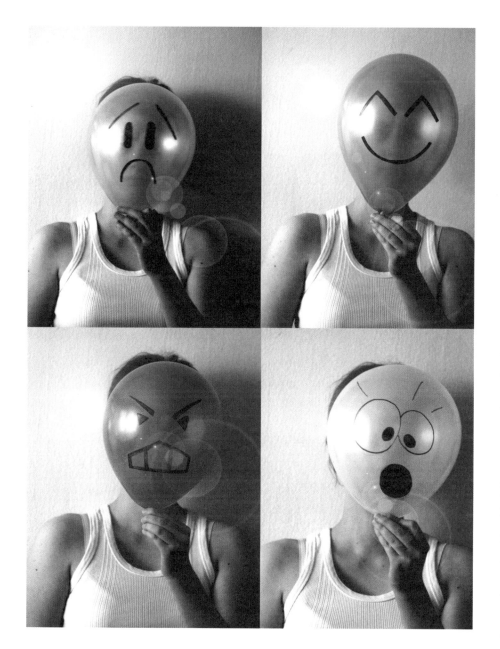

Asja Boros
Emoticons
2008

The simplicity of emoticons does limit their communicative effectiveness, forcing emotions to be reduced to binary extremes. This deficiency has become the subject for a number of artworks. Dave Wood mocks the emoticon's limited potential for expressiveness, layering emoticons over photographs of his distorted face (left). The severity of the distortions reflects how unnatural these facial expressions actually are when performed in real life. Wood's image remarks upon the absurdity of reducing all human emotions to a limited number of basic extremes. Meanwhile, the work of Asja Boros (above) celebrates the anonymity that emoticons offer in an increasingly paranoid age. Wearing emoticons as a mask, Boros is able to express herself while retaining a degree of privacy. Through the semi-opaque balloons, Boros' face is slightly visible, and is revealed as blank and unemotional. These emoticons are false reflections of her real feelings: they actively conceal the truth.

Mirjana Lolic
Emoticons
2007
www.pinninn.com

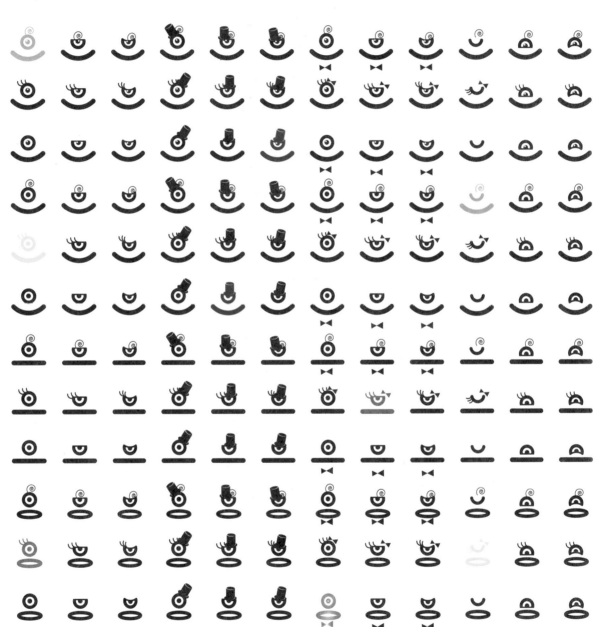

Over the past decade, emoticons have developed into more complex typographic arrangements, capable of depicting entire bodies over several lines of type, further personalising a typed message. Though these arrangements lack the simplicity of the basic smiley, they communicate more detailed information, causing the more basic smilies to look primitive.

These advanced emoticons could perhaps be considered simplistic equivalents to typographic portraits. They depict facial expressions, in a generic form, and are increasingly personalised. Originally asexual arrangements have been expanded over several lines to include gender-specific marks. The feminine curves of parenthesis have been utilized to suggest the female form, while square brackets are reserved for men. Emoticons have even been developed to depict specific well-known individuals: :-.) utilizes the signature beauty mark to represent Marilyn Monroe, while Marge Simpson's tall hair requires parenthesis that extends across 4 lines of type:

```
( )
( )
( )
( )
OO
  >
  U
```

These emoticons are distinguishable from typographic portraits in that, despite their complexity, they do not require the use of graphics software in their construction. Unlike in typographic portraits, where letterforms are defiled—cropped, distorted or overlapped—these letterforms remain untouched. The design of emoticons is not the creative use of letters, but the creative use of space. It is the relative positions of a collection of typed characters—the way in which they are arranged on the screen or page—which causes them to be viewed as an image. By removing or decreasing the space between characters, the designer constructs pictorial configurations. Two or more separate characters, when aligned, become part of a greater whole, perceived as interdependent parts of a shared configuration, rather than independent forms.

Barbara Brownie
Oui, Monsieur
2010

5 Character Design

Type is fundamentally different to biological creatures, belonging to an entirely different ontological category[1]. Type is inanimate, whereas humans and animals are animate, cognisant, and unique. As we have seen in the previous two chapters, in the creation of typographic portraits and emoticons, humans demonstrate the need to attribute human characteristics to type. In anthropomorphising type, typographers transform the inanimate into the animate, erasing the divide between these two fundamentally different categories.

When transformation occurs, it is generally expected to occur within a single ontological category: tadpoles transform into frogs, and acorns transform into trees, but a tadpole cannot transform into an oak tree. Most transformations which defy ontological boundaries are considered fantastical, if not impossible. Yet, there seems to be an exception for anthropomorphism. Humans will readily impose human (and even animal) characteristics on inanimate objects[2].

Lying somewhere between emoticons and typographic portraits are typographic character designs. Here "character" is a pun, referring to a human or animal subject as well as forms from which it is constructed. These simple arrangements of typographic forms are more individual than emoticons, and less complex than typographic portraits. In their construction, they require the use of graphics software (containing layering and rotation that is not available in most word processing packages), and yet these transformations of type to image do not try to conceal their typographic origins. They remain visually very reminiscent of standard type. They are constructed from relatively few typographic forms, which generally remain whole, so that the linguistic meaning of each character can be easily identified.

There is personality in the simplicity of these arrangements. Like comic book or cartoon characters, these typographic characters are constructed from the minimal number of forms required for expression. There is no superfluous decoration to detract from the most expressive parts of the image. The only features that exist are those that are fundamental to the character. Lauren Chaikin's *Self Portrait* (overleaf) contains only those features which convey the characteristics which the artist finds most representative of herself. The long hair defines the character as female, while the rosy cheeks, squinting eyes and cheery smile suggest a jolly temperament. Any additional information about Chaikin's appearance is unnecessary: neither skin texture nor the presence of a nose would contribute to connoting jolliness, and so there is no need to include them in the image.

1 Kelly, Michael H., and Keil, Frank C., 'The More things Change...', Cognitive Science, Vol. 9, Issue 4, 1985, pp. 403-416, p. 404.

2 Boyer, Pascal, 'What Makes Anthropomorphism Natural: Intuitive Ontology and Cultural Representations', The Journal of the Royal Anthropological Institute, Vol. 2, No. 1, 1996, pp. 83- 97, p. 83.

Catherine LaPointe
Bunny
2008
clapointe.daportfolio.com

typo
graphy.

David Karlstrom
Typography Monster
2009
heydave.tumlr.com

Kenneth Turner
Angry Mouse
2008
wolfkinstudios.daportfolio.com

In arranging type to create a character, Chaikin has endowed typographic forms with new values. These forms now have a social significance that they would not have in linguistic communication. By anthropomorphising type, we invite it to invoke a different response[3]: a personal, human response. We anthropomorphise cars and computers so that we may talk to them when they please or frustrate us, and, likewise, we create human and animal characters from type so that we may imagine interacting with them. Type is a tool —we have total control over how we arrange it on the page, but if we can consider it as cognisant, we can image being able to communicate with it: for it to understand us as we understand it.

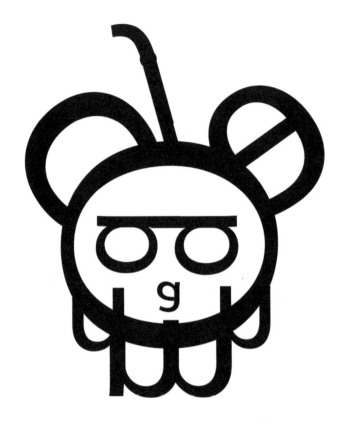

3 DiSalvo, Carl, and Gemperle, Francine, From Seduction to Fulfillment: The Use of Anthropomorphic Form in Design, 2003. http://anthropomorphism.org/pdf/Seduction.pdf

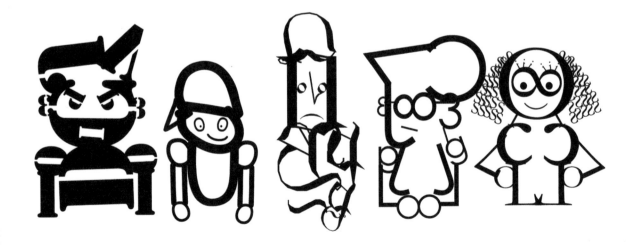

Arie Hadianto
Font-mily Feud
2008
BLUEgarden.deviantart.com

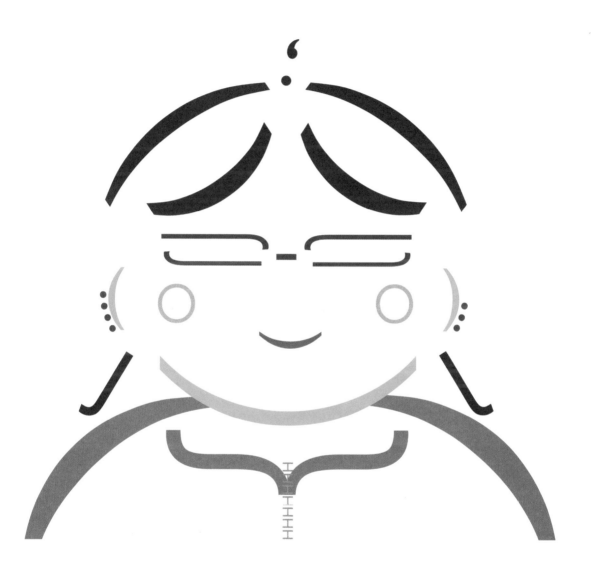

Lauren Chaikin
Self Portrait in Type
2007
laurenchaikin.com

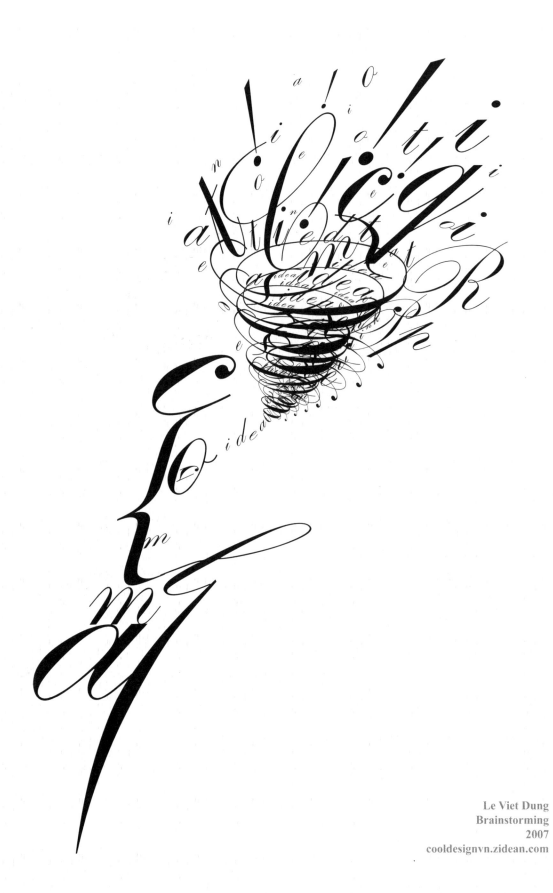

Le Viet Dung
Brainstorming
2007
cooldesignvn.zidean.com

Rafael Chaves
Cooper Black Elephant
2008
rafaelchaves.carbonmade.com

Jens Jørgen Hansen
The Owl Ulla
2005
flickr.com/bogtrykkeren

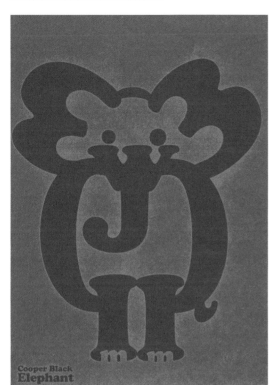

Raquel Arana
Illustration for Fable
2007
shetobu.devaintart.com

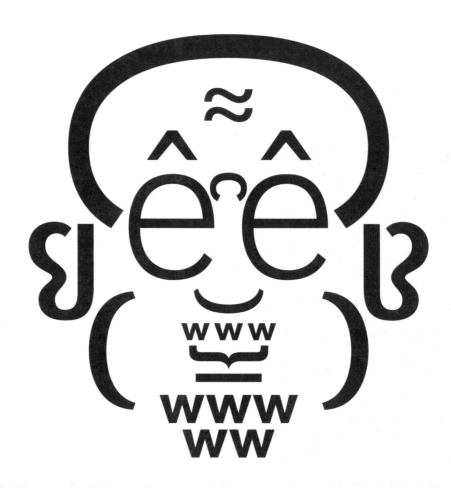

Chris Lozos
Dezcom TypeFace
2004
dezcom.com

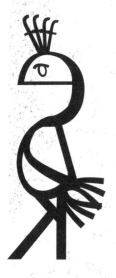

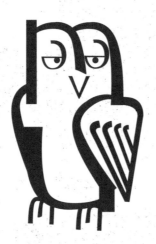

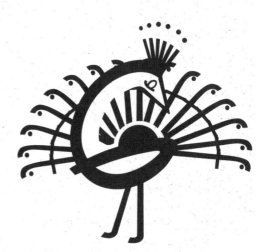

Alisha Giroux
Fowl Type
2008
agiroux.com

Chris Lozos
Type Police
2004
dezcom.com

SLAB SERIF

Slab serif faces have heavy square serifs and were widely used in the 1800s on broadside posters, handbills and advertising. With their relationship to the Industrial Revolution, these faces have a real "workhorse" feel about them. A London type foundry called slab serif faces "Egyptian" as a response to an interest in Egypt at the time and the name stuck.

There are three kinds of slab serifs. Regular slab serif faces have unbracketed serifs and are low in contrast. Clarendon faces have bracketed serifs, ball terminals, and a bit more contrast. Finally, some slab serif faces are monospaced and are used for typewriters.

Rockwell has an odd serif at the apex of its capital A.

Slab serifs have heavy serifs and low contrast.

Afgo

SCRIPT	24 PT
GLYPHIC	20 PT
LINEALE	18 PT
SLAB SERIF	16 PT
DIDONE	14 PT
TRANSITIONAL	10 PT
GARALDE	8 PT
HUMANIST	6 PT

018450

BESLEY, ROBERT
FANN STREET FOUNDRY

CLARENDON

ABCDEFGHIJKLMNOPQRSTUVWXYZ
abcdefghijklmnopqrstuvwxyz0123456789

SCRIPT

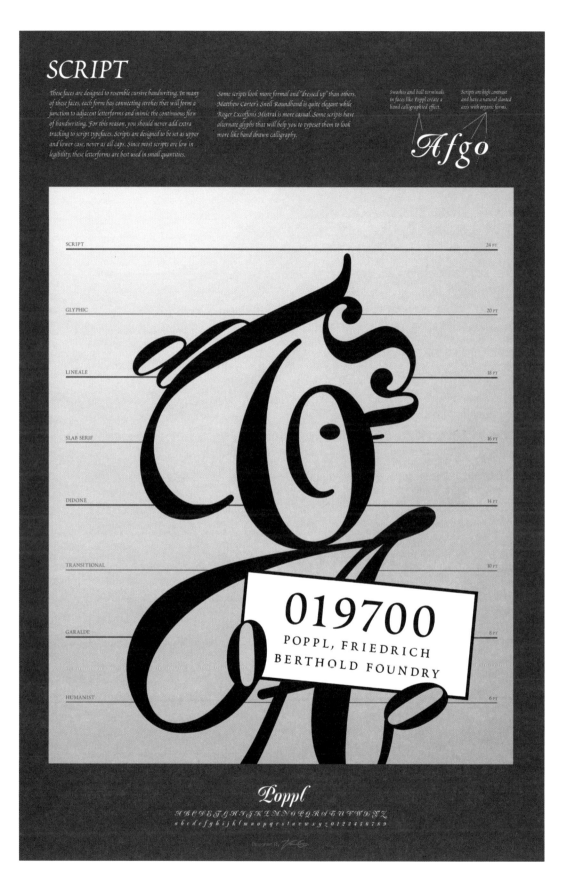

Valerie Spencer
Vox Family Mugshots
2007
www.humanskin.net

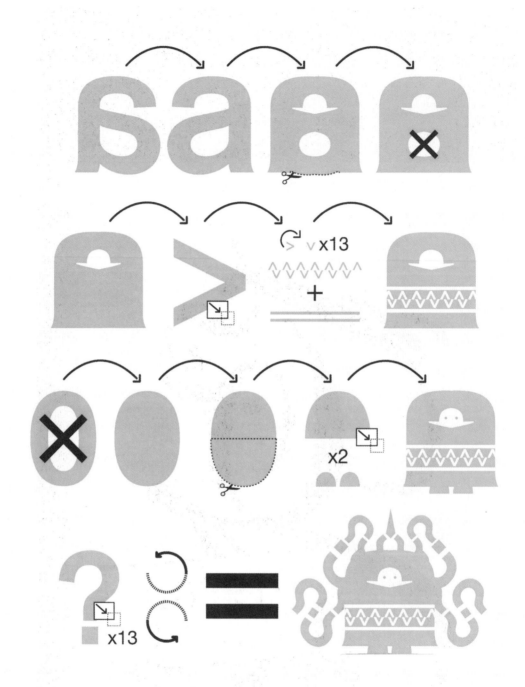

Julián Dorado
Making of Akzidenz
2007
flickr.com/typefaces

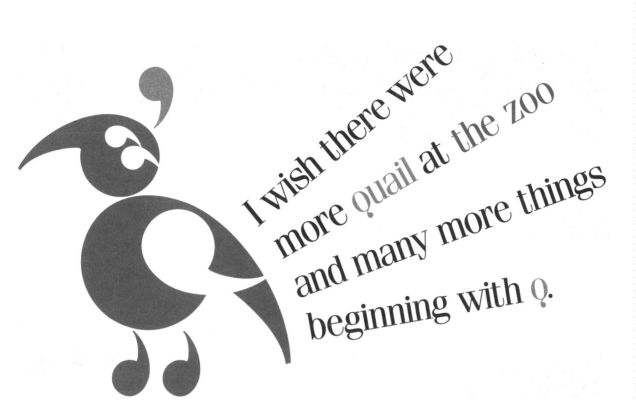

I wish there were more quail at the zoo and many more things beginning with Q.

Jeope Wolfe
The Zoo
2007
flickr.com/joepe

Jose Antonia Perona
La Jara en Verano
2008
flickr.com/perona

Julián Dorado's *Making of Akzidenz* (far left) illustrates the creation of a typographic monster. In this image, an apparently non-typographic creature is sequentially constructed, beginning with a large lower-case "a". Elements borrowed from additional letters are added and subtracted, resulting in an interplay of figure and ground.

Dorado's illustration demonstrates the usefulness of the typographic palette. The alphabet provides a variety of forms which, when deconstructed and combined, may allow for the creation of any number of possible pictorial outcomes, many of which bear no noticeable resemblance to type in their completed state.

As Jose Antonia Perona and Jeope Wolfe demonstrate (left and above), the creation of typographic creatures can be far less complex than in Dorado's monsters. Both Wolfe and Perona have created birds from a limited number of overlaid quotation marks. The organic curve of this particular typographic form allows the entire body of the bird to be represented as a single mark, with another overlaid as a wing. Wolfe's quail, like Dorado's monsters, includes positive and negative forms, while Perona uses layers.

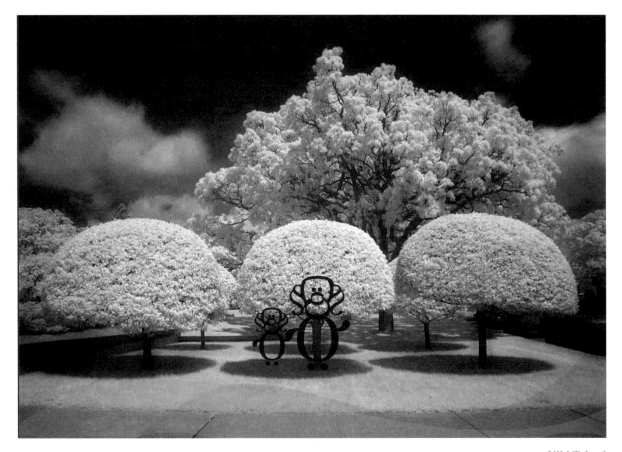

Kiki Tohmé
Fanzine
2009
www.kikitohme.com.br

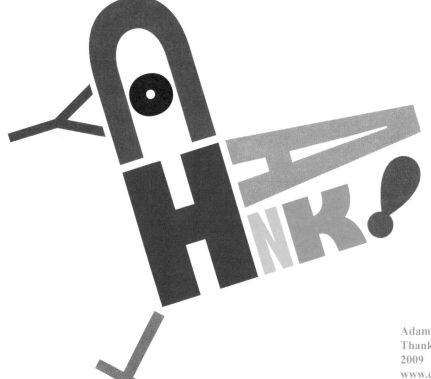

Adam Poole
Thank You Bird
2009
www.coroflot.com/adam_poole

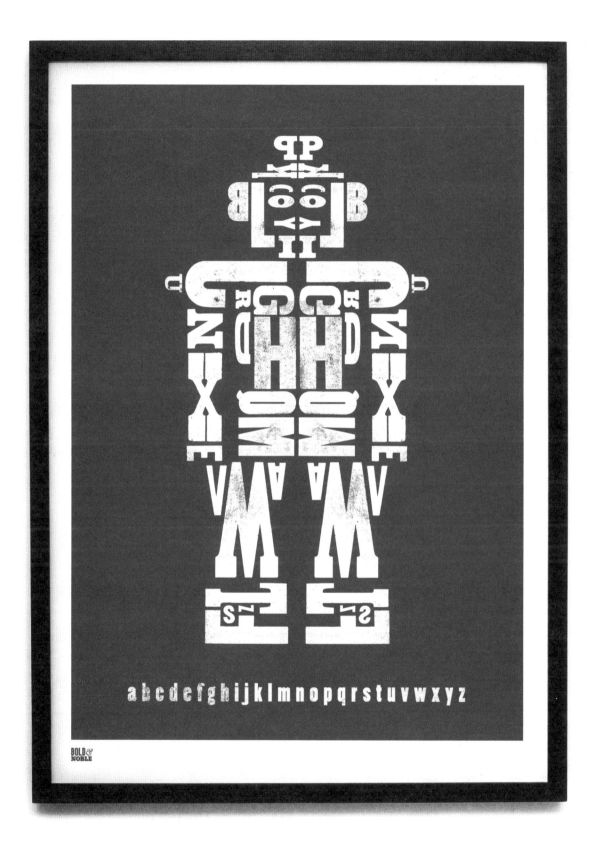

Bold & Noble
Alphabot
2008
www.boldandnoble.com

Parul Kanodia
Typo Gods
2009
behance.net/parulkanodia

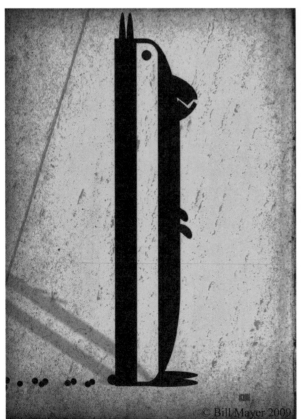
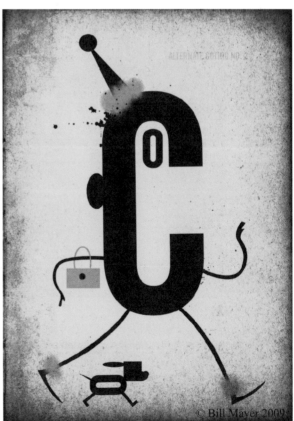

Bill Mayer
D and C
2009
flickr.com/billmayer

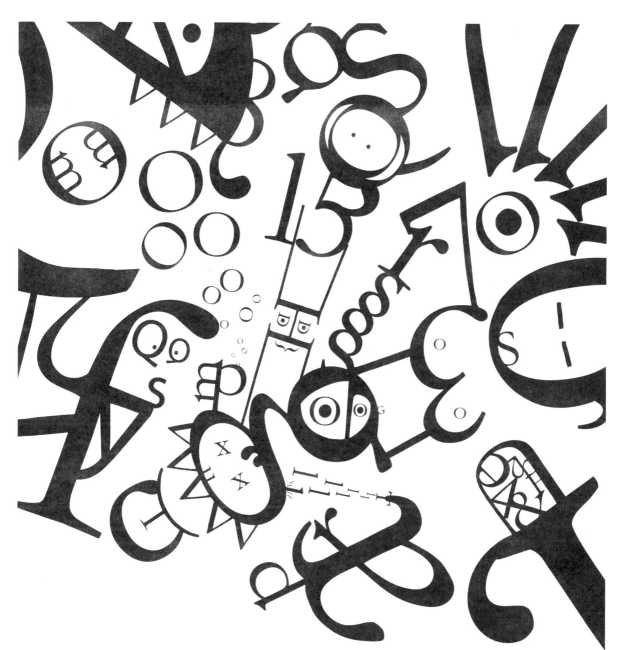

Garamond

Kevin van der Kooi
Letterproef Garamond
2009

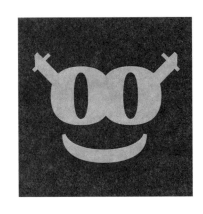

Kiki Tohmé
Fanzine
2009
www.kikitohme.com.br

Anthropomorphism extends to action. People, particularly young children, like to imagine inanimate objects as being engaged in voluntary action. Stories describe inanimate objects that have desires to be something or somewhere else, or that are magically able to move or change.

Typographic character design often extends to narration. More and more frequently, sequential illustrations are being constructed from type. Lauren Chaikin's *Knight of Type* (overleaf) is engaged in action. This image is selected from a collection of sequential illustrations depicting a battle between a dragon and a knight made entirely of type. The knight is depicted interacting with other typographic creatures, and navigating a typographic landscape. This project is more than just character design. The knight, and therefore the type from which he is constructed, comes to life. He engages with his environment, transforming the whole page, and all the type contained within it, into apparently interactive space.

Le Viet Dung's *A Private Life of Billy* (overleaf), depicts a single character in multiple situations. Billy may not interact with the page, but like the *Knight of Type* he is shown engaging in activity. Here, type performs different functions in different locations. As part of the baby, Billy, type performs as image, but as part of the captions above, it is intended to convey linguistic meaning. The two forms of type are separated by a pink box. This pink box signifies as to the intended function of the type. Any type contained within the box is meant to be read, and any type outside of the box is meant to be viewed as part of an illustration.

Grant Walker
Baskerville
2009
www.typeandglyph.com

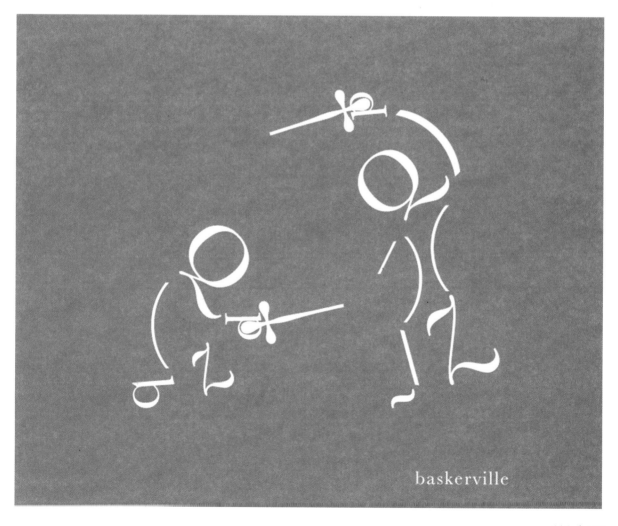

baskerville

Lauren Chaikin
Knight of Type
2007
laurenchaikin.com

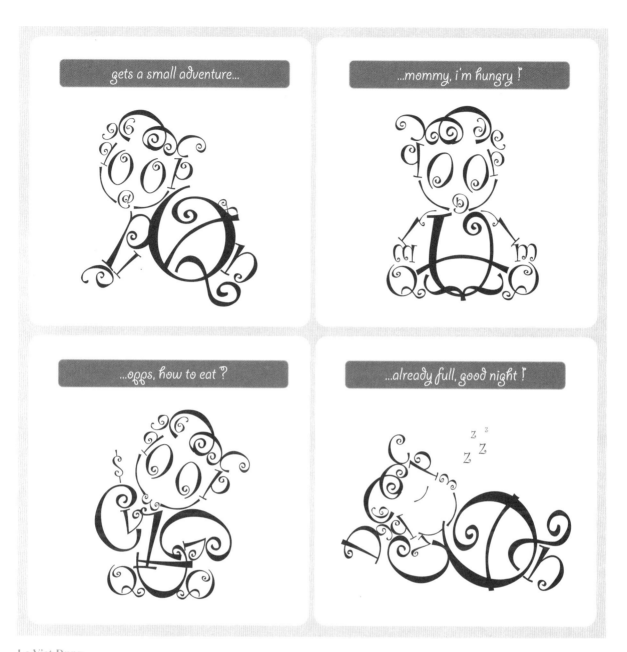

Le Viet Dung
A Private Life of Billy
2008
cooldesignvn.zidean.com

6 Texture & Pattern

Typography has given designers a new set of primitives from which they can construct any kind of image or ornamentation. From the moment Futurist typographers broke away from the confines of the grid, type has had the potential to express non-linguistic meaning through its relative size, rotation and position. The layering of type by early postmodern typographers such as Greiman and Carson demonstrated that letters can act as the small units from which larger textures and patterns can be built. In recent years, typographers have advanced this practice by experimenting further, and integrating typed pattern or texture with image.

The use of type in a non-linguistic artefact, through the elimination of verbal signification, removes type from its association with sound. But far from limiting type to the visual domain, typographic texture invites another sense to become involved — the sense of touch[1]. Visual texture represents tactile texture. In that respect, it allows sight to act as a "stand-in" for touch. As with three-dimensional type, this suggests that type belongs in the realm of the tangible, the physical, the tactile.

Texture gives a painterly feel to typography. The overlapping strokes of letterforms mimic brushstrokes. This essentially treats typography as surface rather than substance. It is the covering, not the content of the image. And yet, many instances of typographic texture have no content beyond the type. They operate as studies of texture, with no additional subject.

The regularity of typographic forms adds a mechanical feel to these textured images. Perhaps counter-intuitively, the textures that typographers create attempt to mimic the natural surfaces of animals, plants or landscapes. In these instances the regularity of type becomes camouflaged through irregular layering and distortion.

1 Dondis, Donis A., A Primer of Visual Literacy, MIT Press, USA, p. 55.

Berk Kizilay
Chaos is My Name
2008
palax.deviantart.com

The apparently natural surfaces that can be created using type in this way rely on a degree of randomness, suggesting the appearance of forms that have been organically produced. Razan Suliman's *Moon Surrounded by Me* (below) combines regular typographic forms with irregular composition. The apparently chaotic arrangement of letterforms contributes to the impression of a natural texture. Layered beneath the texture are a number of floral forms. These flowers compensate for the chaos of the type, each having a regular number of petals, and an unnaturally perfect silhouette.

More often than not, this apparent randomness is also evident in the choice of typefaces. Many typographic textures, including Kelly Kingman's *Alphabet Soup* (right), combine multiple typefaces in an effort to make the image appear organically irregular, even chaotic. Through technically lettering rather than type, Danny J. Gibson's *151 Conversations* (overleaf) demonstrates that letters can perhaps be viewed as organic forms. Although man-made, scrawled lettering is not natural. It is a means of communication that is as natural to humans as gesture and speech. By layering handwriting of different colours and styles, Gibson has created a visual impression of the sound of many people speaking at once. The chaotic texture represents a cacophony of sound. Each word, though it may have been recognisable independently, becomes lost in the texture, just as an individual voice is difficult to distinguish in a noisy crowd.

John O'Grady
Zeus and Thor
2008
flickr.com/jmo-ydargo

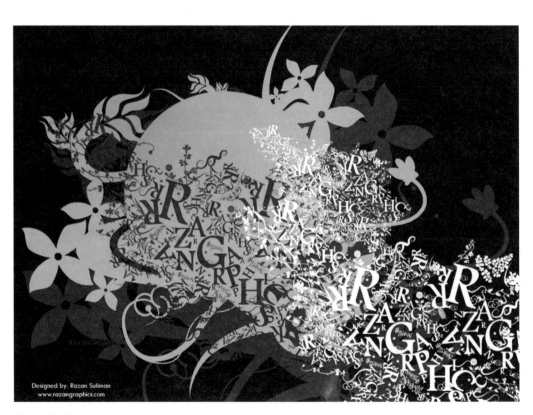

Razan Suliman
Moon Surrounded by Me
2007
razangraphics.com

Kelly Kingman
Alphabet Soup
2008
www.kkingman.com

Barbara Brownie
Fitcher's Basket of Gold
2009

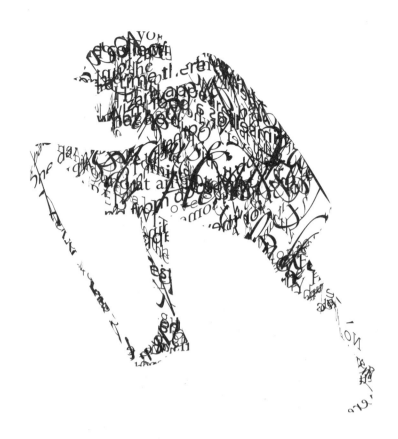

Barbara Brownie
Curtains
2009

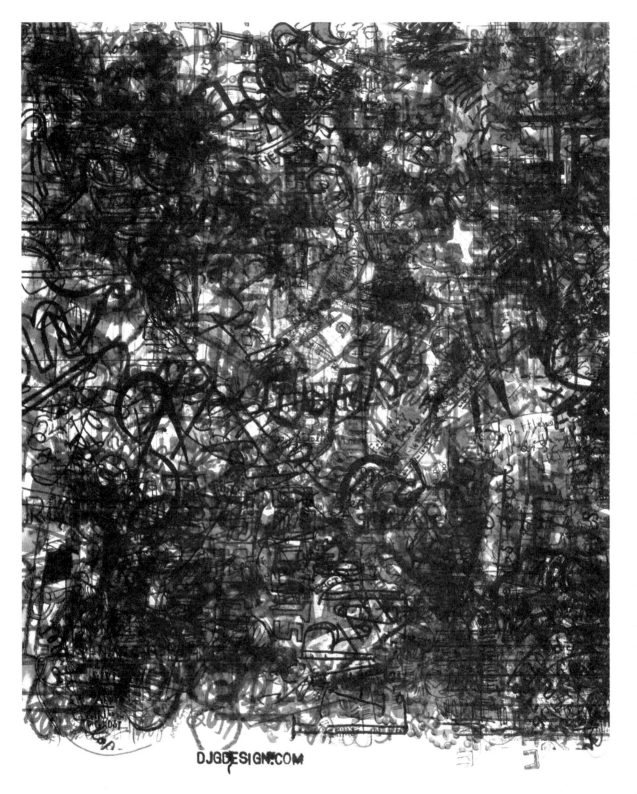

DJGDESIGN.COM

Danny J. Gibson/
DJG Design
151 Conversations
2007
www.djgdesign.com

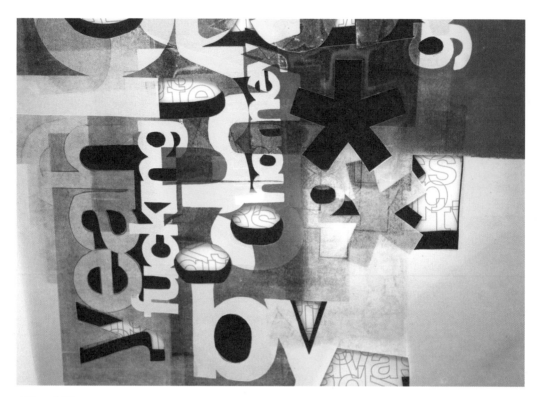

Allison Wilton
.dot com
2008
www.allisonwilton.com

Ian J Curtis
Onomatopoeia Comic Spread
2009
silverbulletdesign.co.uk

Barbara Brownie
Curtains II
2009

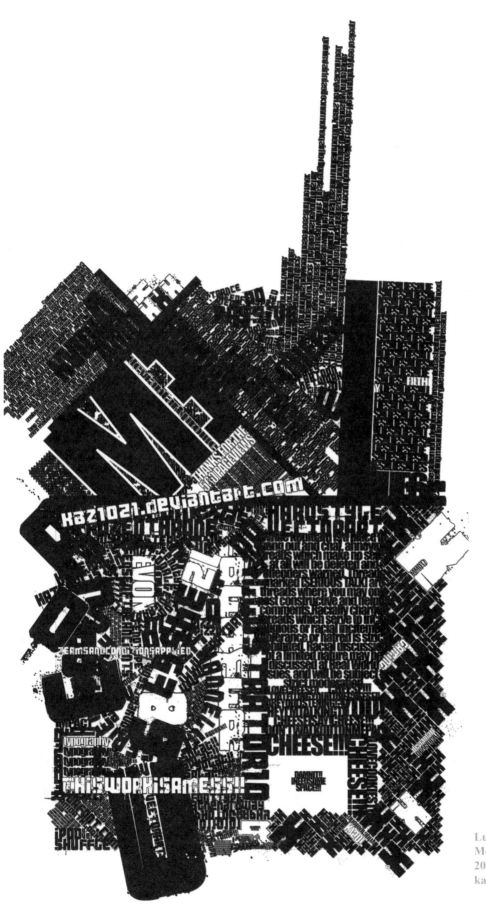

Luke Chanis
Messy
2006
kaz1021.deviantart.com

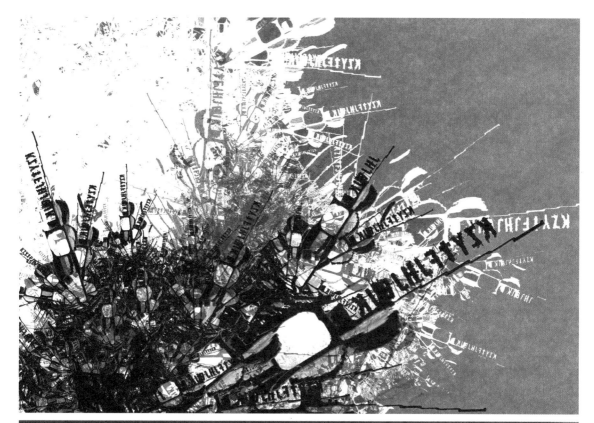

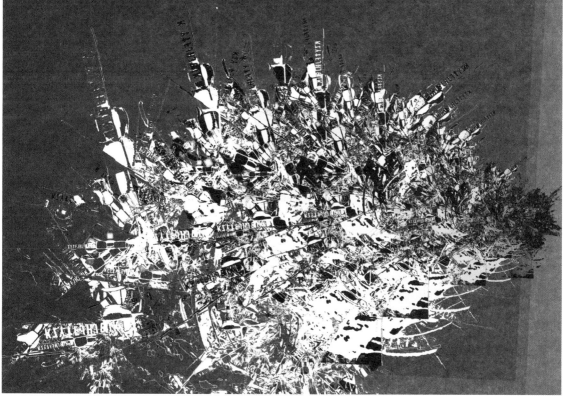

Julieta Cossari
Fractales Colour
2006
flickr.com/julietacossari

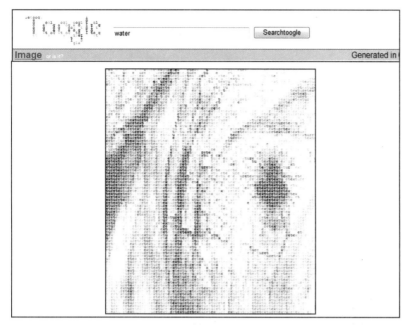

c6
Toogle
2004
www.c6.org/toogle

Christopher Tarampi
Font Collage
2008
www.estheticcore.com

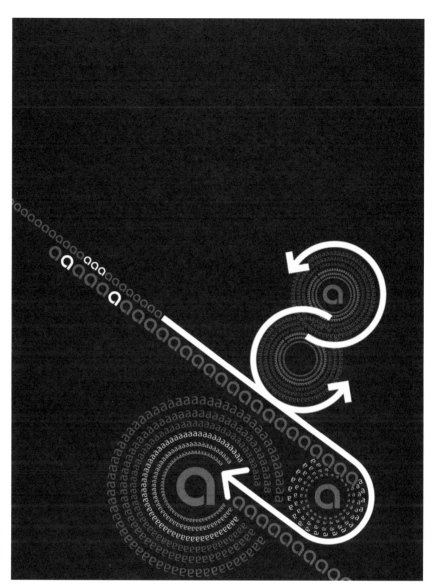

Andreas Leonidou
Typo-A
2007
www.flickr.com/andreasleonidou

Typographic patterns and textures may either be designed or generated. *Toogle*, designed by the c6 group, converts results from a Google Image search into typographic compositions (top left). The search term is tiled to form a typographic texture, and colours are sampled from the image appearing highest in the relevant image search. The results resemble ASCII images, with regular lines of type forming the building blocks of a larger image. As with ASCII art, these generated images are constructed from text which may be copied and pasted into word processing software. This allows users to manipulate the image by changing the character and paragraph settings. In contrast to Christopher Tarampi's *Font Collage* (bottom left), Toogle creates a typographic texture that is artificially regular. This alphabetic texture

resembles a woven surface, or low-resolution print, where an image must be constructed from an orderly sequence of regular shapes.

The process of generation hands some responsibility for design to the audience. In a designed piece, the designer has total control over content and composition. In generated images, however, the designer is only responsible for a template; a code; a set of rules by which the image is generated. It is the audience who chooses the particular content. In this way, projects such as *Toogle* are examples of the shift in author/reader relationships that has occurred as a consequence of new technologies.

There is very little to separate texture from pattern, though perhaps the key factor is regularity. A pattern is generally more repetitive than texture, involving calculated repetition of key elements[1]. All forms of language contain patterns: the rules governing our language, dictating regular arrangement of phonemes, separate them from meaningless noise. In type, the patterns of correct speech are replaced by patterns of visual forms, though in usual prose, verbal patterns are not repetitive enough to be recognised as visual patterns. In order for letterforms to become the smallest units of a pattern, they must be repeated more frequently, more precisely, than in linguistic communication.

Typographic patterns often do not communicate linguistically. They render letterforms illegible by rotating and overlapping them, and, due to the fact that most words do not contain enough repetition for a visual pattern, letters are selected for their shape rather than their linguistic potential. Often, the number of letters used is kept to a minimum, to increase the regularity of the repetition. In many cases, only one or two letters are present. John Skelton's *Futur–A-pattern series* (right, and p. 145) relies solely on a single letter, in a single size, and in a single font. The only variation here is of angle: the letters are rotated, then juxtaposed. This simple process manages to entirely conceal the identity of the original letter, demonstrating how fragile the linguistic identity of a typed form can be. In Robin Camille Davis's *Ampersand Pattern* (far right) a similar process is used to construct a pattern from ampersands. Here, many of the whole ampersands remain unobstructed, and yet because the overlapping configurations dominate, these signs go unnoticed. This pattern could be entirely abstract if it were not for the title, which directs the viewer to seek out the linguistic forms hidden within.

1 Lauer, David A., and Pentak, Stephen, Design Basics, 4th edition, Harcourt Brace & Co., USA, 1994, p. 163.

John Skelton
Futur–A–Pattern Series
2009
www.afrojet.com

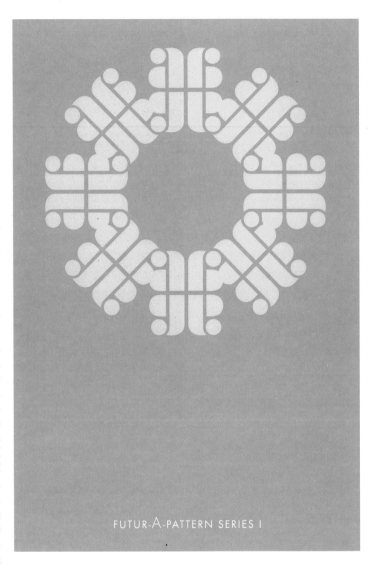

FUTUR-A-PATTERN SERIES I

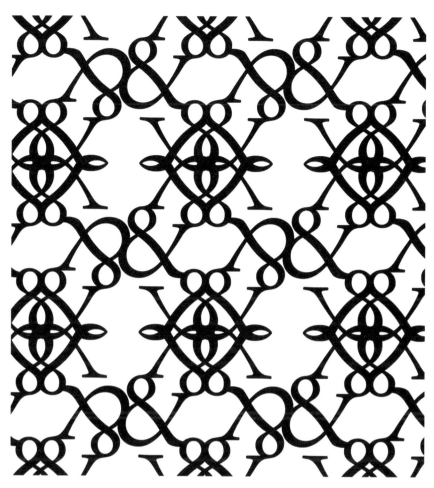

Robin Camille Davis
Ampersand Pattern
2008
www.robincamille.com

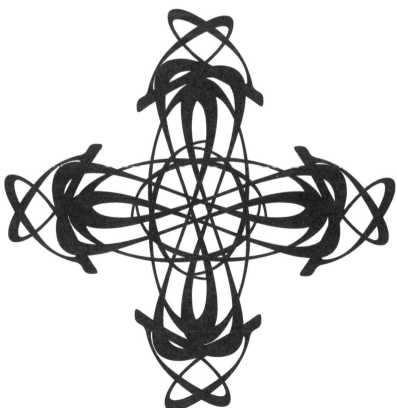

Holly K. Whitney
Letter Series #18
2005
hollykwhitney.com

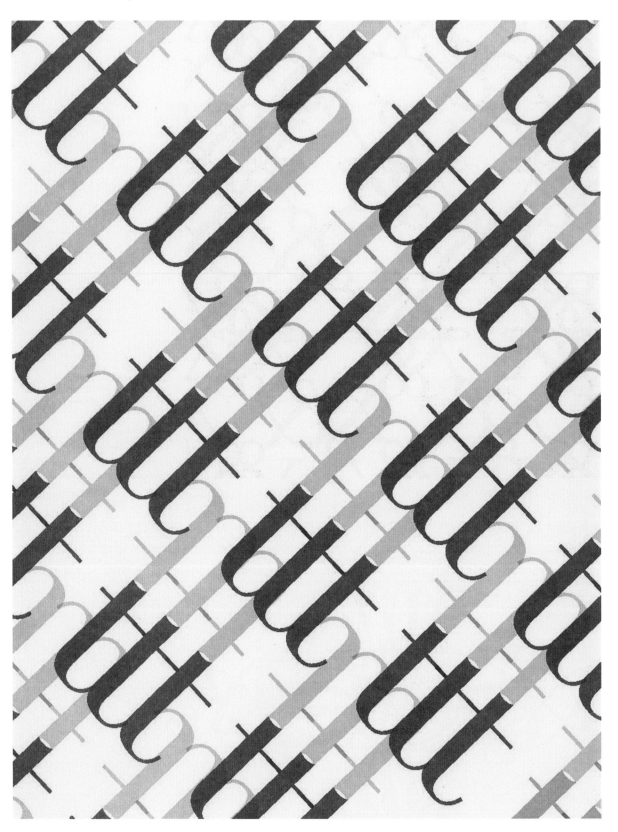

Emily Burtner
Green T Pattern
2008

Mara Hernandez
Cycle
2009
flickr.com/vizhwel

[overleaf]
Barbara Brownie
Escher Alphabet
2009

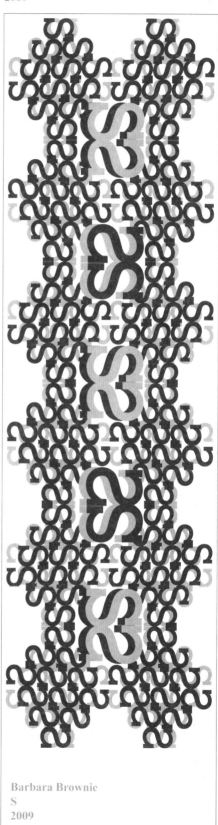

In any typographic pattern, font plays a significant role in determining character. The style of the typeface brings connotations to the image. Serifs add intricacy, causing Roman fonts and scripts to create more regal patterns, while sans serif typefaces tend to create much bolder, geometric arrangements. The addition of colour helps to remove these artefacts a step further from standard type, as with Emily Burtner's *Green T Pattern* (left), in which the use of green causes the pattern to resemble an aerial view of a stylised meadow or other organic surface.

Barbara Brownie
S
2009

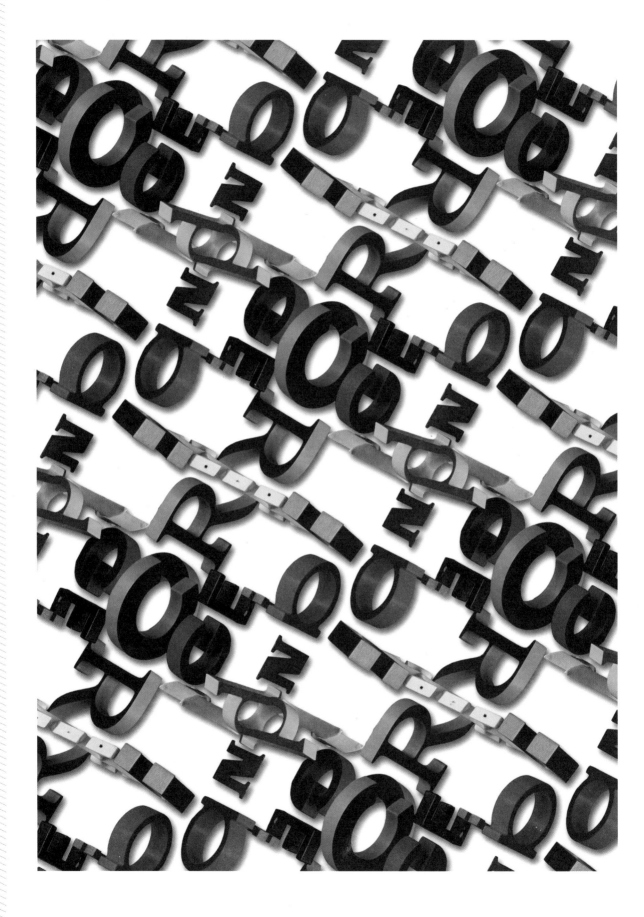

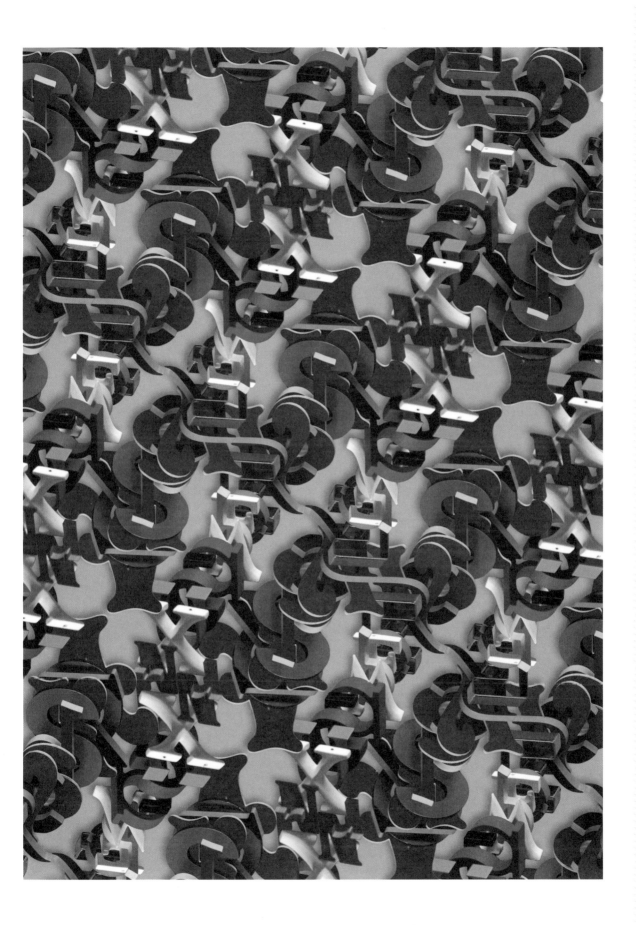

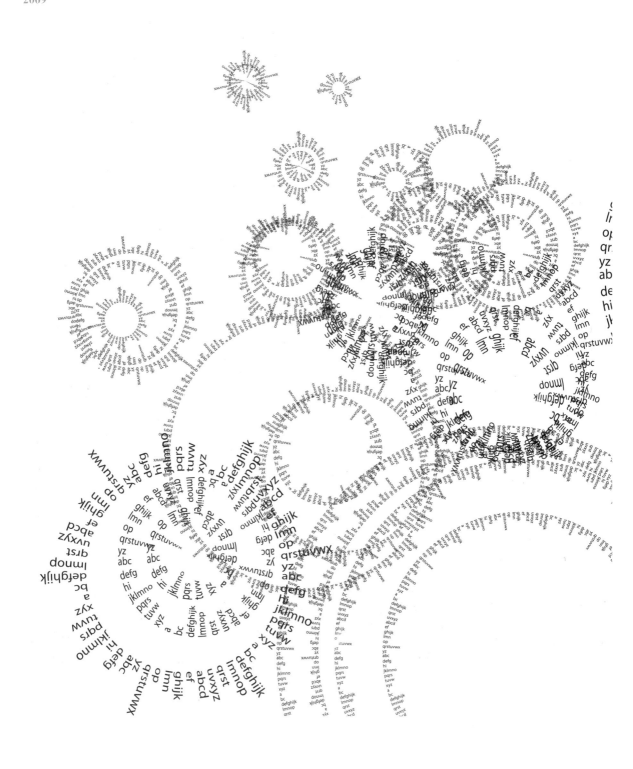

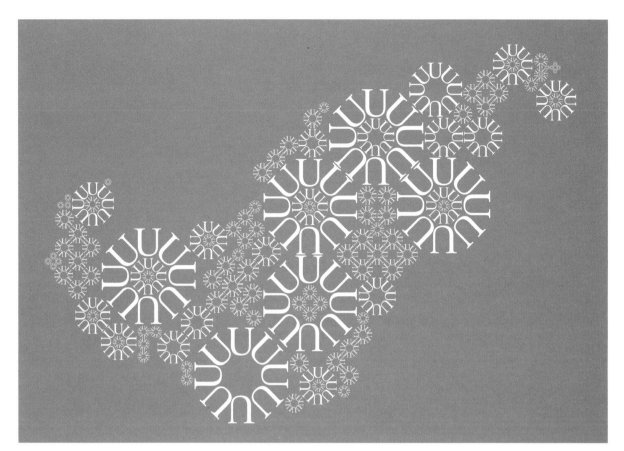

Robin Camille
Sabon U
2008
www.robincamille.com

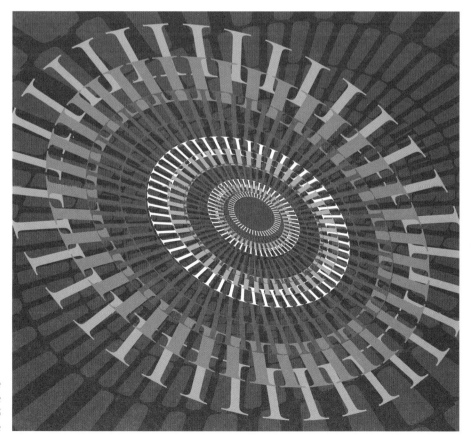

Barry See
Letter I—Initiative
2005
flickr.com/beesee

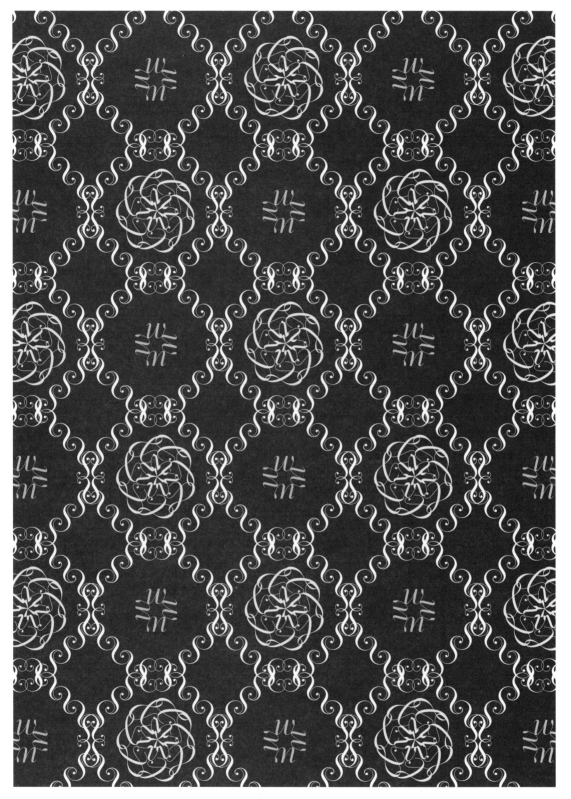

Bonnie Nguyen
Dorchester
2009
beevy.deviantart.com

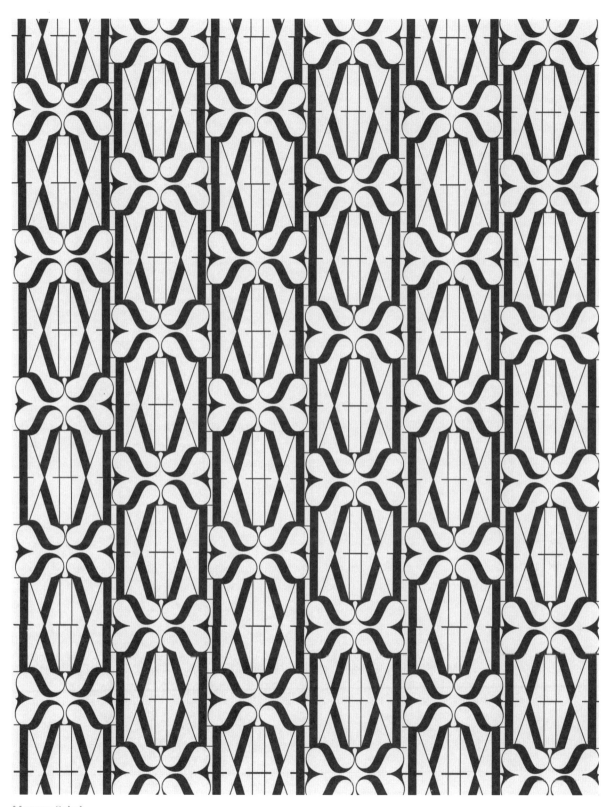

Morgan Sobel
Initial Pattern
2008
molyso.blogspot.com

Amir Chasson
Spillage 23SE.1
2007
www.amirchasson.com

Amir Chasson
Spillage 205C7
2007
www.amirchasson.com

Although many typographic patterns preserve the shape of a letter, Amir Chasson deliberately conceals the linguistic identities of the letters that are used in the construction of these patterns (far left and above). The addition of colour helps to reinforce the impression that these are pictorial rather than linguistic arrangements. The knowledge that these patterns are indeed typographic turns Chasson's work into a challenge—a game of "find the letter". The alphabetic forms are not immediately obvious, but are identifiable for viewers with the patience to seek them out.

Barbara Brownie
qf
2009

Simon Page
Typography is Everything series
Revolution
2009
simoncpage.co.uk

Meagan Buratto
(Worker Designs)
Butterfly and Ampersand
2009
workerdesigns.com

Kristin Joiner
Six22 Press
White Noise
2009
kristinjoiner.com/622

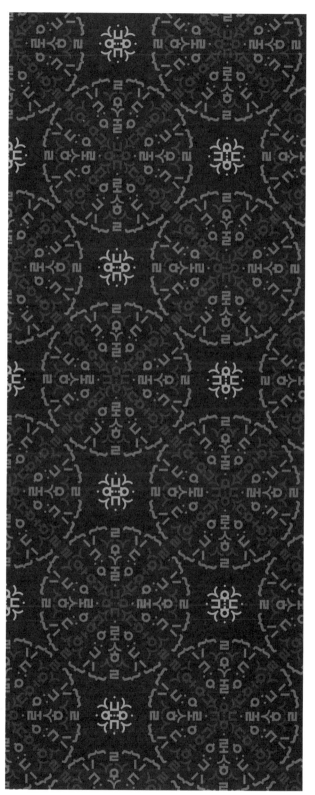

Vhan Kim
Corean to Corea
2010
vhan-artworks.com

Luarni Sim
TapesTry
2008
messymaru.deviantart.com

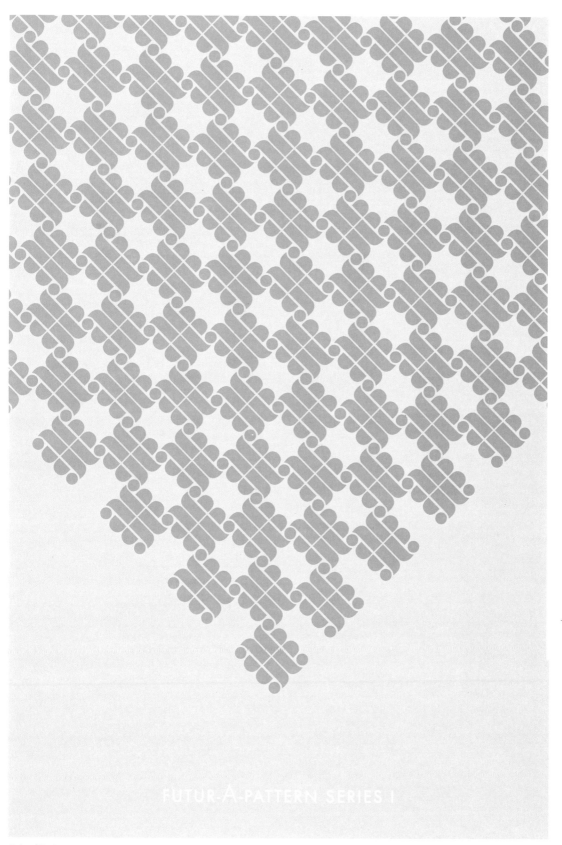

FUTUR-A-PATTERN SERIES I

John Skelton
Futur–A–Pattern Series
2009
www.afrojet.com

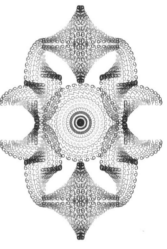

Barbara Brownie
Ornaments
2009

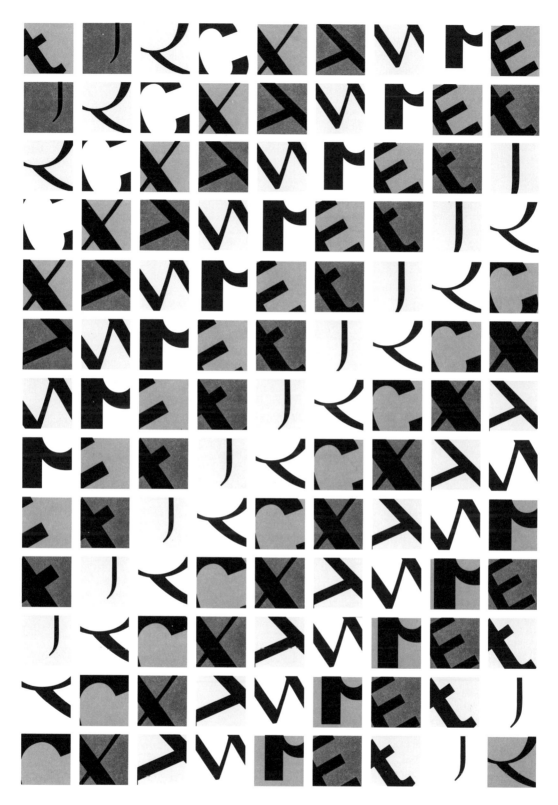

Kyle Rose
Type Poster
2007
www.kaksel.com

Vian Peanu
Typographic Patterns Vol. 2
2009
www.behance.net/oktav

Cary Da Costa
Zilverstad Pattern
2010
dacostadesign.com/work

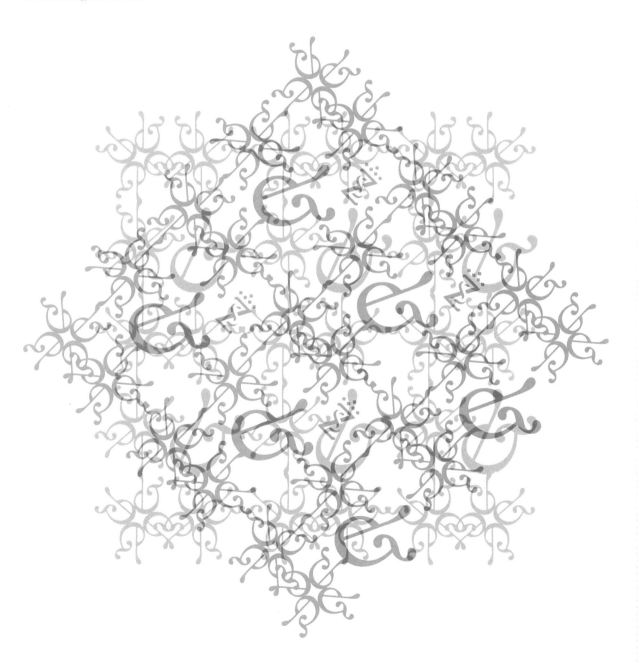

7 Picture Fonts

No letter in the alphabet has a fixed form. Any letter may be manipulated, decorated, or sliced apart, while retaining its alphabetic identity. "Alphabets come in infinite diversity: in some letters are simple, in others, complex and complicated, fantastic and extravagant." The variety of typefaces available to us reflects the diversity of the signs that appear in the handwritten models for type: "every child that learns to write invents its own" form of the alphabet "as distinctive as fingerprints"[1].

From the earliest forms of print, typefaces have shared the page with ornament. Alphabetic forms have themselves been manipulated and decorated, but they have also been placed alongside entirely abstract or pictorial ornaments. These ornaments are created and printed in the same way as type: type and ornament rest alongside one another in the printer's tray. Ornament and type are only distinguished from one another at the point of perception, when the reader finds either linguistic or pictorial meaning in the print.

The relationship between the keyboard and the image is a complex one. Although the keyboard is labelled with alphanumeric characters, its keys may be pressed in order to prompt the appearance of pictorial forms. In pictorial fonts, images are assigned to members of the standard character set.

There is a fine line between fonts that are pictorial and those that are alphabetic. Decorated fonts may communicate linguistically, retaining recognisably alphabetic characteristics, but may also include pictorial elements. Fonts such as Evgeniya Skorobogatova's *Masked Ball* (right) simultaneously communicate linguistic and pictorial messages. Used in appropriate text, the pictorial message may compliment the linguistic message, reinforcing meaning. Such fonts may also be used subversively, challenging linguistic meaning by appearing in text that appears to convey a contradictory or unrelated message.

Entirely pictorial fonts, such as Will Scobie's *Faced* (right), contain no trace of the alphabet. Their relation to alphabetic type is only that they are created using keystrokes. Each pictorial form is rooted to a key on the keyboard, thereby having an unbreakable relationship with an alphanumeric character.

The numerous available dingbat fonts include pictorial motifs, as well as partly or entirely arbitrary signs and symbols. While some symbolize objects or events in a relatively iconic manner, others are ornamental, designed as surface decoration, and some are instructions to the viewer, directing his or her reading. Microsoft's *Wingdings 3*, a typeface consisting of a collection of arrows, directs the readers attention, indicating the relative importance of particular forms on the screen or page, and triggering movement of the eye. The arrows themselves attempt not to be part of the text or image in which they appear. They are not within the text, but on the text, layered over it, in order to suggest a preferred reading. The reader's response should not be to appreciate the arrow as a visual form, nor to attempt to read it directly, but to actively reassess other parts of the text.

1 Gooding, Mel, and Rothebstein, Julian (ed.) Alphabets and Other Signs, Thames & Hudson, London, 1991.

Evgeniya Skorobogatova
Masked Ball
2009
piruli.ru

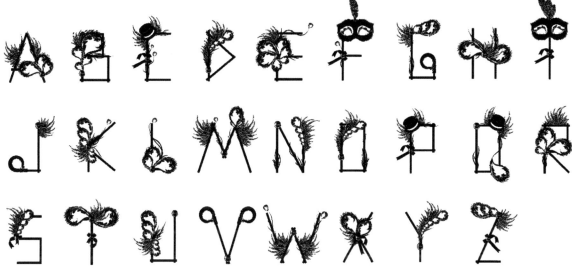

The pointing hand, index or manicule, is as established in type as any alphabetic character, appearing in some of the earliest typefaces of the fifteenth century, and, before print, in illuminated manuscripts from the twelfth century onwards[2]. The manicule traditionally indicates the beginning of a new paragraph, or a passage of particular importance. It later drew attention to products and events in nineteenth century signage and advertising. Although pictorial, the manicule does not merely describe the shape of a hand. The point is a sign from another language: the language of gesture. In typing the manicule, the typographer does not slip from verbal language into pictorial language, but into the language of the hand, which tends to be, like written text, arbitrary. The pointing gesture, like the written word, references objects or events beyond itself.

2 H. Sherman, William, Toward a History of the Manicule, 2005. http://www.livesandletters.ac.uk/papers/FOR_2005_04_002.html

Will Scobie
Faced
2008
reveriecreate.co.uk

Just as the appearance of a letter varies in different typefaces, the manicule appears in reductionist and ornate forms. Represented as a simple arrangement or curves, or an ornamental image complete with tonal variation and a drop-shadow, the appearance of the manicule may reflect the style of the font in which it belongs. More often than not, however, the manicule is an anomaly. Though other non-alphabetic characters are reduced to suit the style of a font, the manicule is frequently the most decorated sign in any character set, displaying more details, more pictorial features, than its sister signs.

The manicule by no means stands alone as a pictorial typographic form. Typographic ornaments allowed early printed books to resemble illuminated manuscripts. The above samples (right) from *Bodoni Ornaments* depict floral motifs. These ornaments do not reference plants and flowers directly; they are depictions of established architectural embellishments. They are, in effect, self-referential: ornamental signs depicting ornamental objects. Bodoni's *Manuale Tipographico*, from which these samples were originally taken, was compiled in the eighteenth century, when Bodoni himself would have been exposed to the extravagance of Baroque and Rococo design. His symbols bear closer resemblance to the architectural mouldings of his era than the natural forms on which they were based. A similar observation can be made with regards to contemporary typographic ornaments, which often overtly reflect the properties of printed, moulded or embroidered surface decoration. *Cadence*, by Jonathan Perez for Typographies.fr (right, below) includes forms that may be tiled, allowing a user to type a repeat pattern. Like *Bodoni Ornaments*, *Cadence* is largely floral, but is less representative of real flowers than it is of existing ornamental designs.

Herman Zapf's 1978 collections of dingbats have no shared aim. They are a miscellany of ornaments and symbols. As a complete set, they do not appear to be concerned with the typing process, however several characters within the set refer to the handwriting processes that typing has replaced. *Zapf Dingbats* include images of fountain pen nibs, pencils, and a hand engaged in the act of writing (overleaf). These symbols mourn the loss of traditional methods, and remind the digital generation that lettering has not always been typed.

Handwriting, and the handmade, are the theme of numerous other digital typefaces. These character sets embrace the advantages of digital printing, while simultaneously displaying the aesthetic of the handmade, imbued with the old-fashioned charm of imperfect, rustic forms. Typefaces like these refer to either the process or the product of handwriting. Selected *Zapf Dingbats* symbolise the creation of writing—the putting of pen to paper. They remind us of the tactile experience of holding a tool in our hands. Tereza Cenic's *Handmade Icons 01*, while not connoting the act of handwriting, represent the imperfections

Morris Fuller Benton
Summer Stone
(based on samples by Giam-
battista Bodoni)
Bodoni Ornaments ITC
1995 (1788)

Jonathan Perez
Typographies.fr
Cadence
2009
www.typographies.fr
piruli.ru

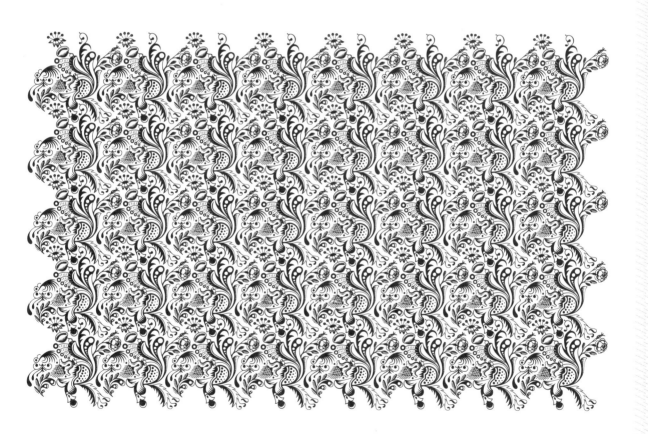

Microsoft
Webdings
1997

of the handmade with their messy, hand-drawn style. Containing angry scrawls, as if mistakes have been scratched out, these icons embrace errors. It is, after all, the absence of errors and imperfections that distinguishes the digital from the handmade.

Cenic's typeface also represents another form of language: the spoken word. The Saussurean view that the written word is a second-order sign, not referring directly to its subject but to the spoken word, is reflected in typefaces that symbolise aspects of speech. Samples from *Webdings* (above) refer to spoken communication, resembling comic-book speech bubbles. Like handwriting, speech is a method of producing language that predates the keyboard, and is perhaps, therefore, more natural than type. These particular symbols are free of any specific linguistic meaning—they contain no letters or words. They do not represent any particular utterance, but the whole of speech, and any possible combination of letters or phonemes.

Hermann Zapf
Zapf Dingbats
1978

Tereza Cenic
Handmade Icons 01
2009
behance.net/egotreep

Kate Toropygina
Cyrillic Font
2009
atelier.ua

Joshua Jay Tetreault
boy. typography
2008
behance.net/JoshTate

[overleaf, right]
Graeme Offord
Home
2009
graemeofford.com

[overleaf, left]
Alex Varanese
Elektrotrash
2009
alexvaranese.com

Although illuminated letters and iconographic alphabets long preceded the invention of digital type, the tradition of manipulating pictorial forms in the creation of an alphabet remains in contemporary typography. Kate Toropygina's *Cyrillic font* (left) arranges feline forms to present the alphabetic characters. Much like nineteenth century iconographic alphabets, this transforms the natural into the artificial. Biological forms, with organic irregularities, are moulded into the regular shapes of the alphabet.

Following similar traditions, Joshua Jay Tetreault's *boy* (above) arranges floral forms in the shapes of letters. Although Tetreault has created an entire alphabet, the most notable application of the typeface is the sample above. Floral forms are traditionally considered feminine, whereas here they are used to present the word "boy".

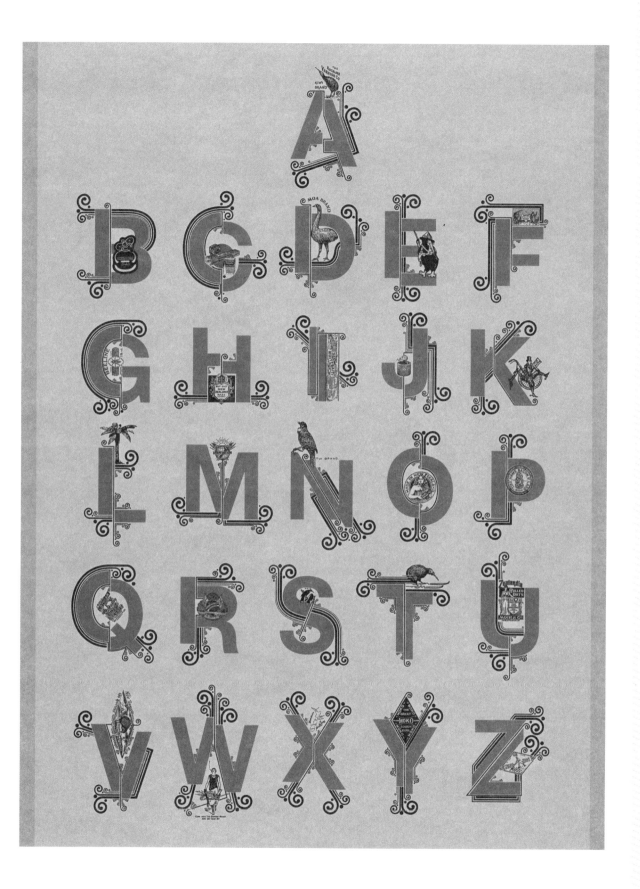

THE QUICK BROWN FOX JUMPS OVER THE LAZY DOG

Anastasia Gerali
Kylos
2009
anastasiagerali.com

Following a Modernist trend established by the Bauhaus and De Stijl (most notably by Josef Albers, Theo van Doesburg and Bart van der Leck), modular typefaces are constructed from an array of regular primitives. Built in this way, letterforms are not wholes, but configurations. A limited set of abstract, often geometric, forms are used like building blocks in the construction of the alphabet. These abstract shapes are interchangeable, able to serve multiple roles according to context.

Manolo Guerrero's *Block02* (right) requires only eight regular forms in the construction of an entire set of alphabetic and numerical characters. Similarly, Anastasia Gerali's *Kylos* (above) constructs letters from segments of a circle. The circles and rectangles used in the construction of *Block02* and *Kylos* are not themselves typographic. Viewed independently of the rest of the configuration, each rectangle could be interpreted as a pictorial form, with no linguistic meaning. These forms, therefore, serve multiple roles: at a micro level, they operate pictorially, and at a macro level, they operate linguistically. The pictorial nature of Gerali's primitives is reinforced in her use of the same forms as the ears in an image of a fox.

There is, in these typefaces, a "double articulation", in which, just as in language meaningful words can be broken down into less meaningful, interchangeable phonemes, a letter may be broken down into non-linguistic component parts[1]. Those parts, when removed from the letter, are capable of independent significance, distinct from their roles as a part of a configuration. The coloured segments of *Kylos*, for example, are seen as significant pictorial forms when appearing in a different context—an image of a fox. When they appear within a letter, however, that additional meaning must be abandoned in favour of the linguistic interpretation.

1 Holemstein, Elmar, 'Double Articulation in Writing', in Coulmas, Florian, and Ehlich, Konrad (eds), Writing in Focus, Walter de Gruyter, NY, 1983, pp. 45-62, pp. 45-55.

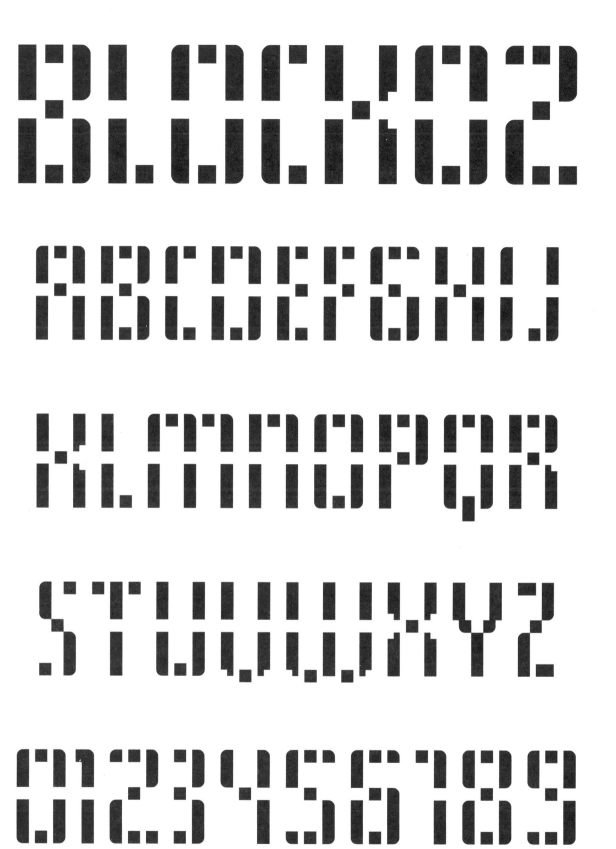

Manolo Guerrero
Block02
2009
bluetypo.com

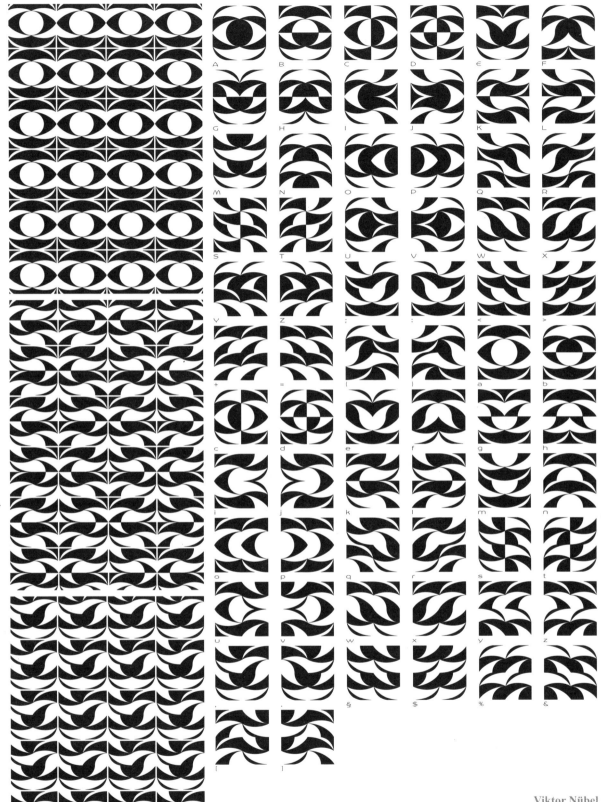

Viktor Nübel
Modul72 (patterns left, and typeface above)
2009
www.viktornuebel.com

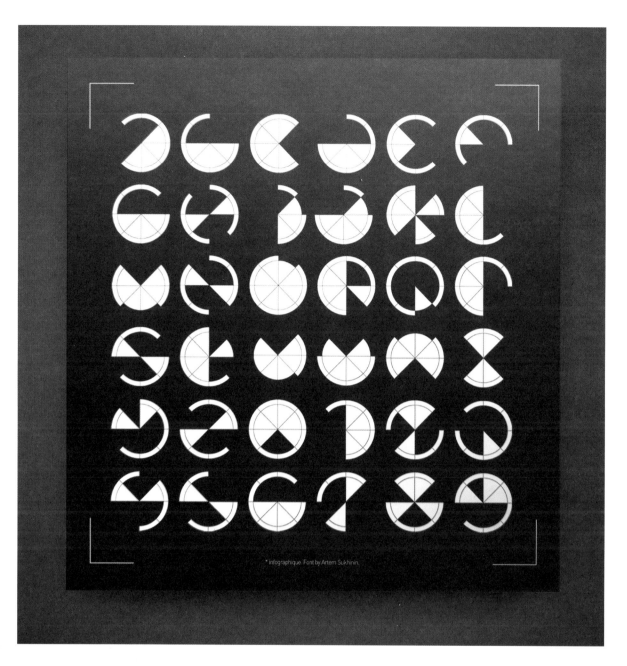

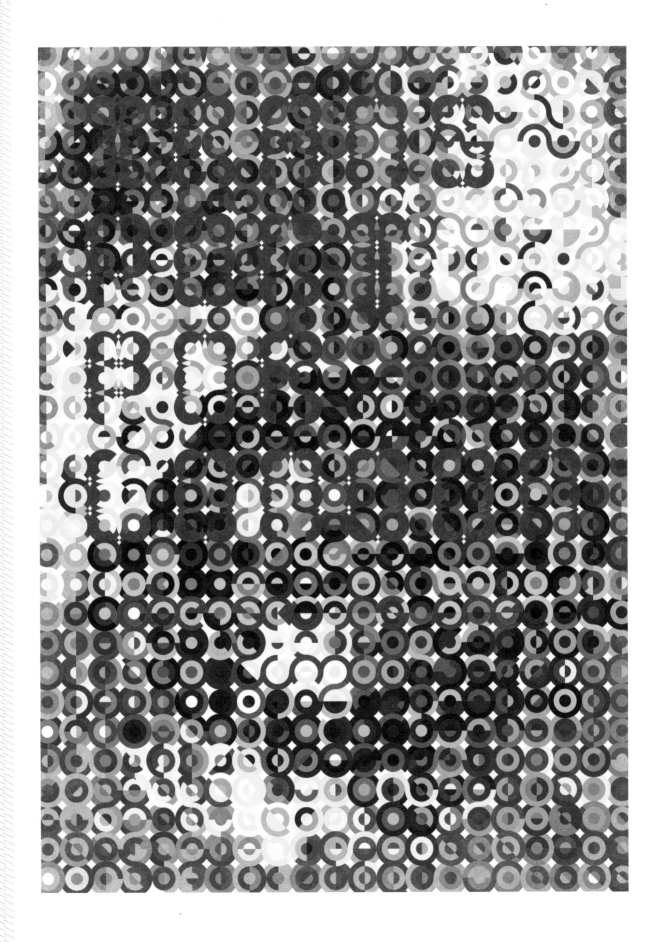

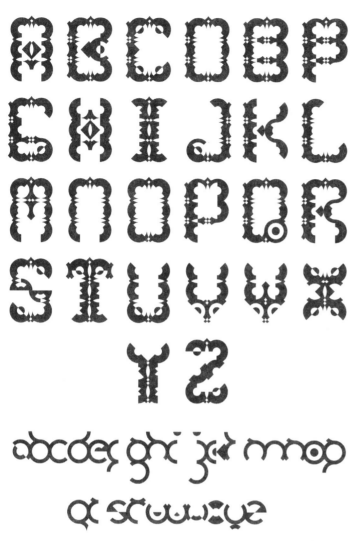

Alex Camacho
Variable Typeface
2009
www.alexcamacho.es

Viktor Nübel's *Modul72* (previous page) extends the notion of modular construction further. Although assigned to the alphanumeric keys of the keyboard, Nübel's characters are barely recognisable as linguistic, if at all. Like Guerrero's *Block02*, each letter is constructed from a set of primitives, and those primitives are interchangeable, but Nübel's intention is not to provide the components of a linguistic message. Much like typographic ornaments, his forms are not used in words, but in patterns.

In Alex Camacho's *Variable Typeface* (left), modular construction is used to create a complex typeface. Each letter of the typeface appears constructed from kaleidoscopic mirroring of geometric segments. Placing his typeface on a background (far left), Camacho demonstrates how easily this lettering may be camouflaged. This image also reveals the process of construction of the whole alphabet: from a grid of hundreds of small concentric circles. The lower-case forms reveal their origins more overtly than their upper-case companions, with each letter built upon a single ring.

In Laura Bertinelli's *Florals Dingbats*, flowers give birth to an array of dingbats. The pictograms appear out-of-place, having no connection to floral arrangements. Dingbats are always out of place. Even in their native environment of type, they do not adhere to expectations. They are pictorial, not alphabetic, and therefore exist in a separate paradigm to most other typefaces. In the first of Bertinelli's images (left), there is at least a symptomatic relationship between the flowers and the dingbats which appear within. Flowers respond to weather patterns, blooming or wilting in response to changing atmospheric conditions, and so the health of a flower could perhaps be an indicator of recent weather. In the second and third images, the selection of pictograms seems arbitrary. In the second (right), various emergency vehicles, and in the third (far right), computer icons. Despite their pictorial nature, these icons do not appear to belong in the image, their artificially regular contours contrast sharply with the organic curves of the plants. This contrast is a reminder that these signs are pictograms rather than simply stylised images.

Laura Bertinelli
Florals Dingbats
2009
www.behance.net/LauraBertinelli

Agency: Atelier Graphique Malte Martin
Creative Direction: Malte Martin
Art Direction and Design: Bruno Bernard
Client: Side One Posthume Théâtre
Posthume
2009
www.brunobernard.com

Slobodan Jesijevic
Tour de Force Font Foundry
Znak Symbols
2009
www.tourdefonts.com

Posthume (far left), a pictographic typeface designed by Bruno Bernard for Side One Posthume Théâtre, samples signs from numerous international and historical sources. The typeface is representative of many cultures and many forms of written and pictorial communication, acting like a survey of the many modes of visual communication that exist throughout the world. Numerous cultures and traditions are brought together to form displays that transcend cultural boundaries. Included and adapted are Ancient Egyptian hieroglyphic, zodiacal and alchemical signs, and even cuneiform. This collection of signs, extracted from many visual languages but collectively native to no time and no place, reminds us of the history and development of our own alphabet.

Raquel Quevedo
Sign Language
2009
www.lasantadesign.com

Teresa Cunningham
Tool Malfunction
2010
teresamarie.net

Type and writing are not the only visual representations of verbal language that are used in contemporary society. Sign language, usually a gestural system, is represented as a typeface by Raquel Quevedo (far left). Quevedo describes her system as a "visual grammar"rather than a typeface, because, unlike standard typefaces, these symbols are not directly representative of alphabetic characters. Instead, this collection of signs represents the shape and relative position of palms and fingers, as they form the sign language alphabet. Many of these signs are simplified images of the hand, while others represent the position of each finger. Here(above), abstract forms represent each of the four fingers and one thumb on a hand, and the relative position of the forms maps the extension of each finger.

Instead of mapping directly onto an existing language, Teresa Cunningham's *Tool Malfunction* responds to established formatting and printing conventions. Each glyph is generated from a set of layered forms. New forms may be generated by the user, by adjusting kerning and leading values. This poster (left) displays the glyphs in layered combinations of Cyan-Magenta-Yellow colours.

Aileen Murphy's *Typodots* (far right) allocates coloured rings and dots to each letter of the upper and lower case alphabet. Michael Green's *Stankowski* (right) also reduces the alphabet to a series of simple shapes. Here, the relative size of each square reflects the usefulness of each letter. The larger squares represent letters that are more commonly used, and smaller squares reflect letters that appear less often. This project operates as effectively as an abstract typeface as it does a piece of information design: displaying information about the exiting application of alphabetic forms, while also providing a tool for the creation of new compositions.

In both Murphy's and Green's projects, alphabetic meaning is only revealed to audiences with privileged access to the designer's underlying concept. For the most part, audiences would experience these alphabets as entirely abstract. In use, the *Typodots* alphabet is a colourful abstract code, its linguistic meaning only accessible to audiences who are aware of the alphabetic equivalent of each dot. Likewise, the significance of each of *Stankowski* squares is revealed only when the audience seeks additional meaning. This hidden layer of significance reflects responses to early writing. All forms of writing are, in their early use, codes for the exclusive use of the literate. This exclusivity, and the knowledge that there may be additional layers of meaning, adds to the allure of new languages and typefaces.

Michael Green
Stankowski
2010
www.twotimesdaily.com

Aileen Murphy
Typodots
2009
www.kerrpinks.com

8 In-Image Captions

When text appears within an image, it can serve to function as a caption. In captions, words help to indicate what Roland Barthes terms the "preferred meaning" of the image[1]. A caption can indicate the most important or meaningful part of the image, parasitically quickening the journey to the artist's intended interpretation[2], either by duplicating selected information from the image, or by introducing related ideas.

Perhaps the most celebrated "in-image caption" is contained within René Magritte's *The Treachery of Images* (La Trahison des Images). Magritte's image of a pipe is accompanied by the words "this is not a pipe" ("ceci n'est pas une pipe"). This caption may appear to present a contradiction, but in fact relates to the nature of the painting rather than its contents. Although the painting may depict a pipe, it is not itself a pipe: it is a painting.

It is rare for images and their captions to reflect each other in perfect symmetry. Pictures and words are, after all, fundamentally different modes of communication, belonging to two different, and not always alternative, paradigms. Though an image and its caption may agree, communicating equivalent messages, either the type or the image will inevitably provide more detailed informations. Most commonly, the caption enhances the message conveyed in the image, or vice versa. The overall aims of the image and text are the same, but one is more detailed or elaborate[3]. In some cases, the messages conveyed in the image and text may deviate from one another, offering alternative or even contradictory ideas[4].

When words appear within an image, they can serve the same function as external captions. The image may enhance the meaning of the text or vice versa, perhaps reducing the many possible interpretations of the image to a single, authoritative message. Stuart Wade's *Summer Time* (right) is a photographic depiction of a tranquil landscape. Any number of elements within the landscape may attract the attention of the viewer — the still water, the dominant boulders in the foreground, or the mountainous backdrop — however the caption, "summer time", tells us that the artist's intention was not to capture a particular arrangement of objects, but the qualities of the season. The blue of the sky, the quality of the light, the green of the plants, signify summer, and it is this particular signification that the viewer must recognise.

In this particular example, the type appears within a photograph. Though type is traditionally a flat, printed sign, Wade's image suggests that this caption is a physical object, fully integrated into the landscape. The letterforms are illuminated from the same direction as the boulders, and are reflected in the surface of the water. This type is not placed on top of the image, but is contained within it.

1 Barthes, Roland, and Heath, Steven (translator), Image Music Text, Fontana Press, London, 1977, p. 39.

2 Ibid., p. 25

3 Lewis, David, Reading Contemporary Picturebooks, Routledge, London, p. 38.

4 Ibid., p. 34.

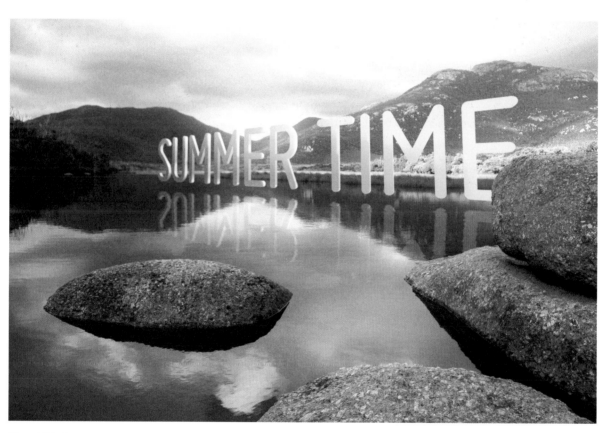

Stuart Wade
Summer Time
2009
www.stuartdwade.com

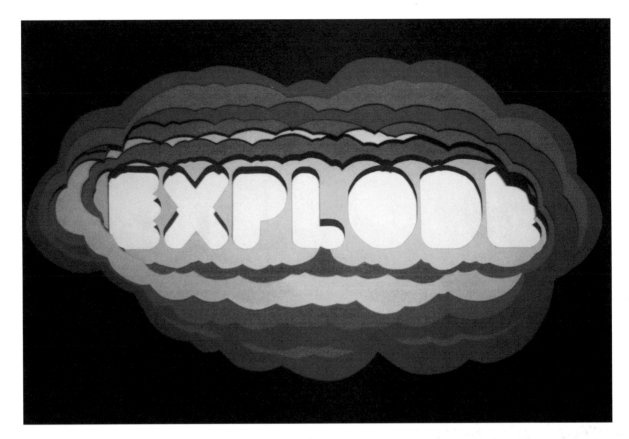

Ryan Riegner's *Typography that Talks Back* series (above and right), use an in-image caption to suggest methods of creation. Though both images have been constructed using cut-out layers of card, the lettering suggests that each caption has come into being by alternative methods, namely explosion and erosion. *Erode* (right) uses the caption to contradict the initial appearance of the image. Though it appears immediately clear that this piece is a cut-out, the type tells us otherwise, suggesting that the lettering has in fact developed over a considerable amount of time, through a natural process of erosion. The connotations of artificial orderliness that would usually arise from type are replaced by associations with a natural, uncontrollable and destructive process.

In *Explode* (above) the image illustrates the text. The words explain the preferred meaning of the images, ensuring that the stylised, reductionist representation of an explosion cannot be misinterpreted. This removes the need for an external caption, making the image completely self-reliant and self-defining.

Ryan Riegner
Typography that Talks Back
(Explode)
2009
www.ryanriegner.com

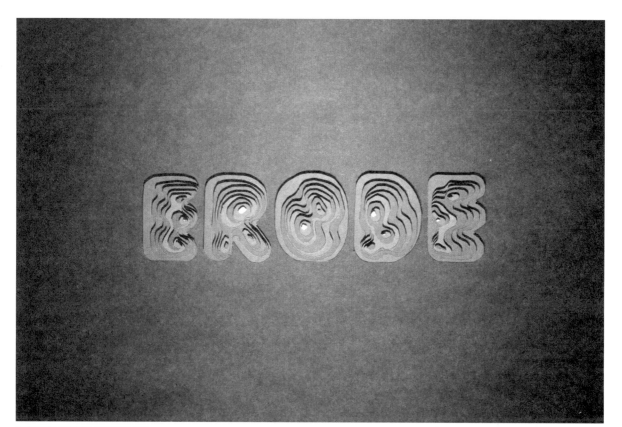

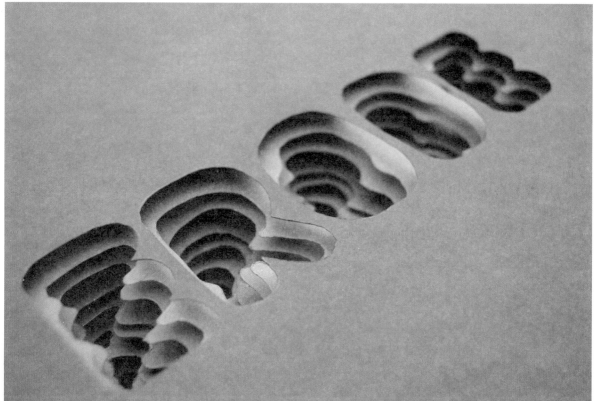

Ryan Riegner
Typography that Talks Back (Erode)
2009
www.ryanriegner.com

Stefan Chinof
Hot Cup of Coffee
2009
chin2off.deviatart.com

The text that appears in Stefan Chinof's *Hot Cup of Coffee* (above), challenges the viewer to imagine a scenario from which the image results. The image depicts a liquid, sloshing onto a surface, and the type tells us that this liquid is coffee, but omits to offer an explanation as to how the coffee was spilt. This invites the viewer to imagine the accident which perhaps occurred a moment before the image was captured.

Breakfast (right) continues the theme of spillage. As the adage, "you can't make an omelette without breaking eggs", this image demonstrates that destructive processes can also be creative. Together, these two pieces paint a picture of a morning in the kitchen, and the inevitable mess that results from a rushed breakfast.

Stefan Chinof
Breakfast
2009
chin2off.deviatart.com

Jamal Ahmad
Bridge
2009
www.jamalahmad.co.uk

Jamal Ahmad
Tree and Road
2009
www.jamalahmad.co.uk

Jamal Ahmad's series of captioned photographs (left and above) convert otherwise mundane or ambiguous photos into more meaningful images through the use of simple, explanatory labels. *Bridge* (far left) depicts an industrial structure which may be anonymous were it not for the addition of the caption. The many possible interpretations of the image are swiftly eliminated in favour of a single "preferred meaning".

Road (left) uses a caption not only to tell the viewer what is depicted, but also to add broader connotations of high-speed travel. The word "road" is split in two, forcing the viewer to travel between two locations in the image. The depicted road connects these two separate locations, making them sequential destinations on a single typographic journey.

Dmitry Karpov
Experimental Illustration
2008
www.flickr.com/anabolicdesign

Rather than clarify meaning, Alex Hohlov's *Allowed* (right) uses type to invite confusion over the possible contents of an image. Hohlov's image is, even on close inspection, apparently abstract. The caption, however, proposes that there may be more significant meanings in this array of shapes. On reading the caption, the viewer must seek out a connection between the type and the abstract forms, and may consequentially impose artificial meaning on the image.

Katia Daniel
Forgotten
2009
irokchukz.deviantart.com

Alex Hohlov
Allowed
2009
www.alexhohlov.com

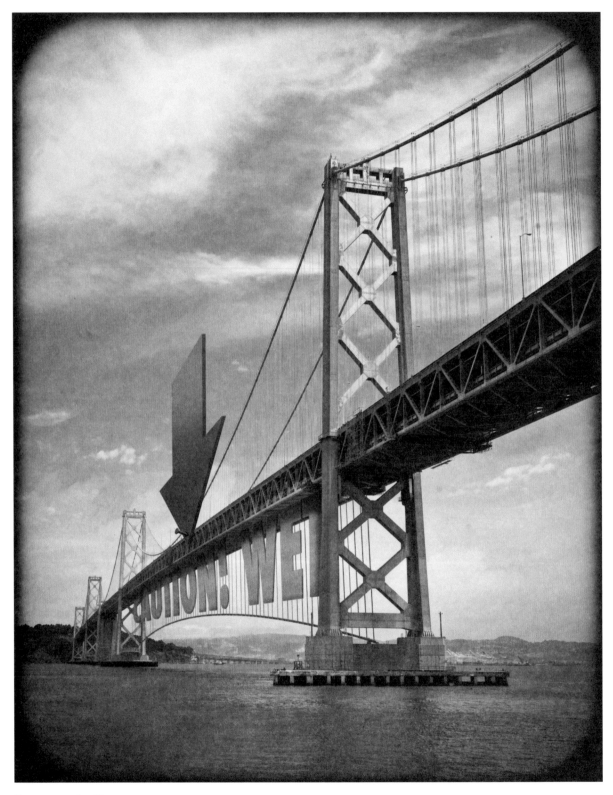

Remco van der Meer
Caution Wet
2009
www.remmac.nl

Guarav Bhadauria
Why Not?
2009
www.bloodyhippo.deviantart.com

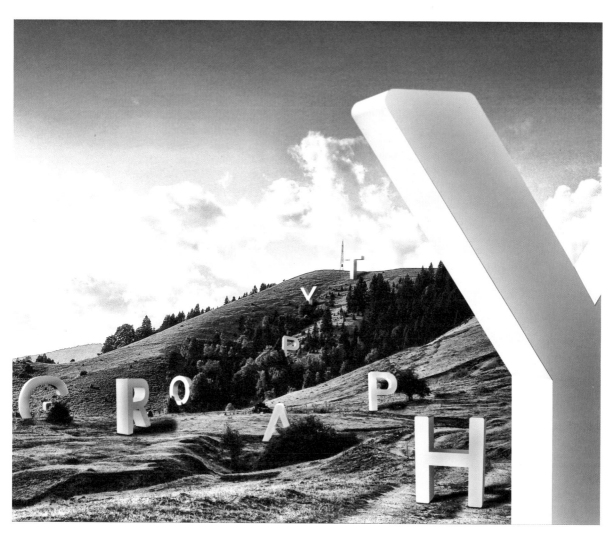

Guarav Bhadauria
Typography on a Hill
2008
www.bloodyhippo.deviantart.com

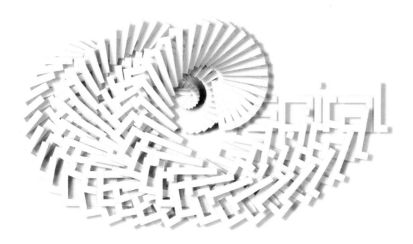

Simon Page
Typography is Everything series—Spiral
2009
www.simoncpage.co.uk

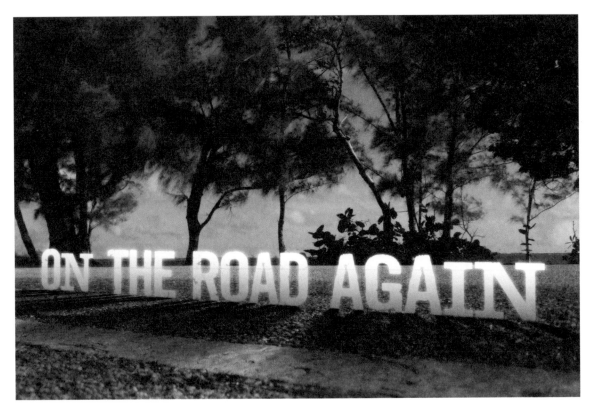

Steve Cardno
On the Road Again
2008
www.stevecardno.co.uk

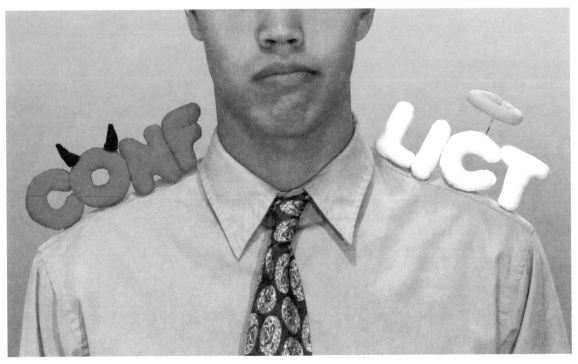

Scott Garner
Expressive Word: Conflict
2007
scott.j38.net

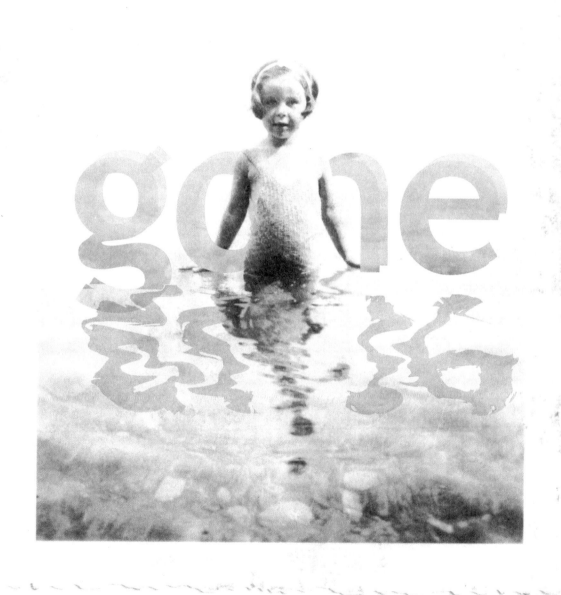

Barbara Brownie
Val
2009

9 The Typed Object

The typed letter, even when contained within an image, remains a flat sign. As object, however, the letter escapes the confines of the page, and can be experienced as a tangible form.

Like the typed image, the typed object has two identities: it is simultaneously word and object. More often than not, it has a practical function, as furnishing, as clothing, or as tableware. Its practical function usually does not detract from its linguistic function, but the words contained within it can reference themes that are entirely removed from the practical function of the object. Susan Angebranndt's *Type Collage Coasters* for Green Chair Press (right, below) are decorated with apparently random typographic characters and ornaments. The randomness of the characters establishes association with the process of printing type, while the mildly distressed appearance of the letterforms, and the choice of traditional ornaments, suggest the use of old wooden printing blocks. S.J.Engraving's collection of engraved pebbles (overleaf) send positive and personalised messages to their recipients. Words such as "cherish" and the dates of memorable events are "cast in stone", preserved for eternity. Here it is not the function of the pebble that reinforces the linguistic message. Stone's association with longevity assures the recipient that the emotions conveyed through the engraved message will not be fleeting, but will last an eternity. In other examples, linguistic messages are not merely surface decoration, but are embedded into the very form of an object. Products by Palette Industries, including the *Dharma Lounge* (right, above) and the *Camus Floor Lamp* (overleaf), are laser-cut stacked letters, folded into the shape of an object. Little Factory's typographic scarfs (overleaf) are also laser-cut, giving the impression of stacked letters. In these examples, there is figure but no ground—the signs form the surface.

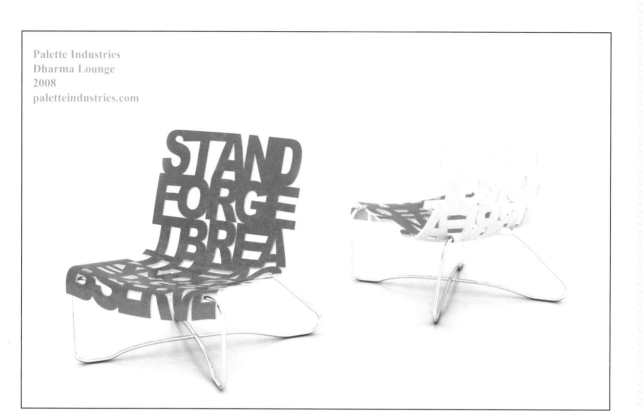

Palette Industries
Dharma Lounge
2008
paletteindustries.com

Susan Angebranndt
Green Chair Press
Type Collage Coasters
2009
GreenChairPress.com

Little Factory
Uppercase Scarf
Lowercase Scarf
2008
littlefactory.com

S. J. Engraving
Engraved Stones
2009
sjengraving.etsy.com

Palette Industries
Camus Floor Lamp
2009
paletteindustries.com

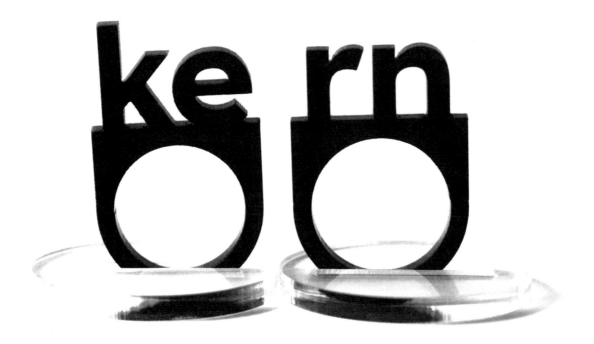

Jen Murse
Plastique*
Kern Ring Set
2009

Jen Murse's typographic jewellery at Plastique* is a prime example of the integration of object and type. These typographic forms (right and above) are laser-cut acrylic, appearing as flat type in their original on-screen inception, then given physical form by the mechanised cutting processes. Directly describing formatting options (as with *Kern*, above, and *Helvetica*, right), these objects overtly reference the typographic process.

Jen Murse
Plastique*
Helvetica Necklace
2009

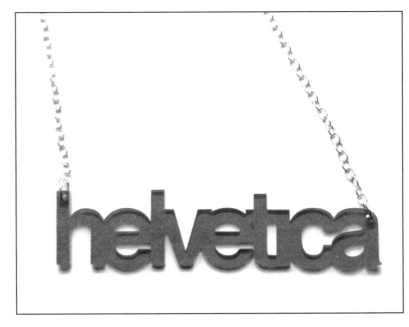

Jen Murse
Plastique*
Undo Necklace
2009
plastiqueshop.com

Michelle Lam
Graphos Playing Cards
2009
www.behance.net/themichellelam

Victoria Herford takes an entirely different approach to making typographic jewellery. Using the lost-wax casting process, Herford creates surface texture from type. For her bracelet and pendant (right), vintage letterpress type is pressed into clay to create a layered typographic texture. Wax, pressed into the clay, forms the mould for the jewellery. This process is one of preservation: casting a temporary wax model as a permanent object. Moreover, it preserves lettering. Metal type is traditionally intended for the production of fragile, often disposable, documents. But here, the same type is used to create letterforms that can be treasured, and that will withstand the test of time.

Murse and Herford, with their very different typographic jewelleries, communicate the same sentiment: that type should be considered precious. It is not only a record of linguistic messages, but also a thing of beauty in its own right, worthy of being on display.

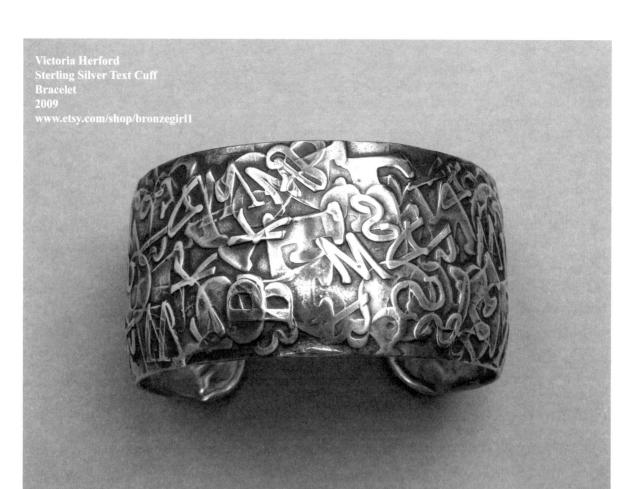

Victoria Herford
Sterling Silver Text Cuff
Bracelet
2009
www.etsy.com/shop/bronzegirl1

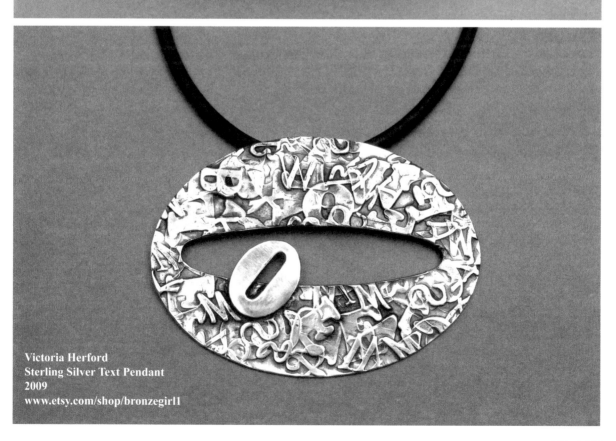

Victoria Herford
Sterling Silver Text Pendant
2009
www.etsy.com/shop/bronzegirl1

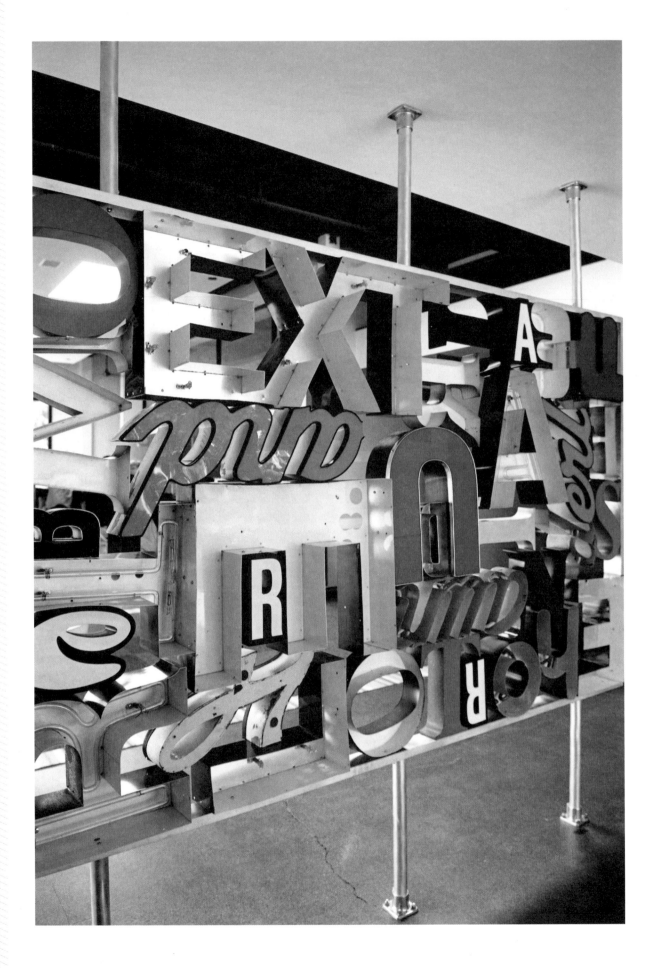

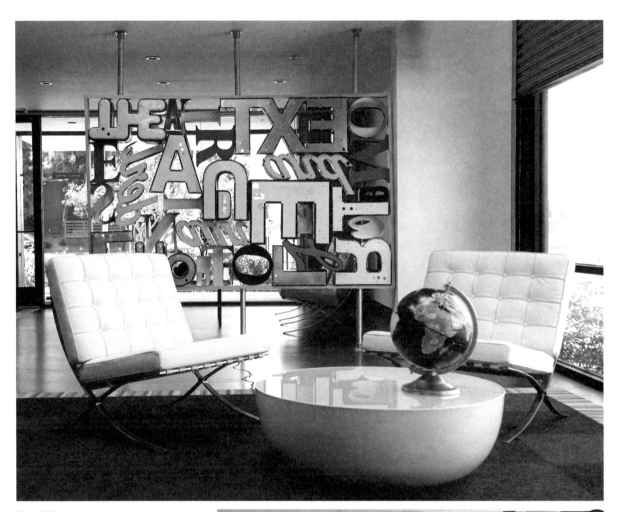

Ron Miriello
Letter Wall
2007
miriellografico.com

Ron Miriello's *Letter Wall* (left and above) divides the lobby and offices of branding firm Miriello Grafico. The wall is constructed from found signage, representing small local firms and major national chains.

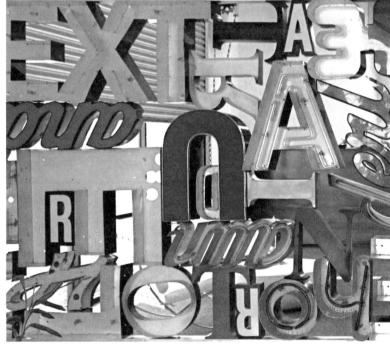

Mark Boroyan
Alex Grey Monument
2009
www.behance.net/MarkBoroyan

Laser cutting techniques have enabled designers to accurately shape solid materials using typographic templates. The laser-cut examples on the previous few pages retain legibility, thanks to the use of sans serif typefaces, and orderly layout. However, Mark Boroyan's *Alex Grey Monument* (above), uses Zapfino, a script font that aims for expression over simplicity and legibility. The initials "A" and "G" are layered, repeated, and then reflected at right-angles to produce a three-dimensional object that is reminiscent of a Christmas ornament.

Ronen Cohen
Ice Typography
2009
flickr.com/ronencohen

Through sculpture, or typographic moulds, it is possible to create typographic objects from almost any substance. Alphabetic cutters (such as the *Helevtica Cookie Cutters* by Beverly Hsu) and moulds (such as those available from Generate Design), allow precise recreation of extruded typographic forms.

In Ronen Cohen's *Ice Typography* (above), the letter "A" is formed from ice. In this image, the "A" is shown in three stages of melting. In the first, it is fully formed, and clearly alphabetic, but as it melts it loses its alphabetic identity. Here, the most significant aspect of the object is not its form, but how it changes during its transformation from solid to fluid.

Camille Baudelaire
3D Typography
2009
www.camillebaudelaire.com

More often than not, the typed object remains a virtual model, never manifests in a physical form. Though only viewed on a flat screen, virtual objects are imagined as having equivalent properties to real objects. The virtual environment offers the opportunity to add features which would be difficult to replicate using real materials. Camille Baudelaire's three-dimensional letterforms do not simply extrude flat letterforms. Each letter's contours are distorted: stretched, twisted, and skewed. In some cases, the resultant object appears organic, as if grown from an alphabetic seed, while others seem mathematical (including the "N"s far right) appearing to be constructed from stacked forms, with each repetition displaying slight variation.

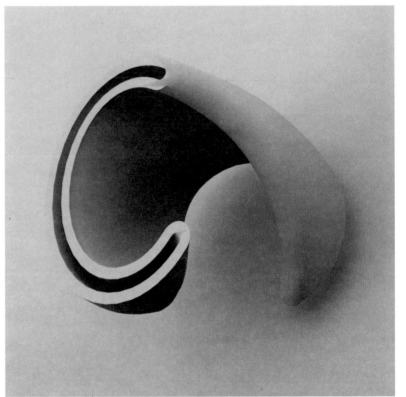

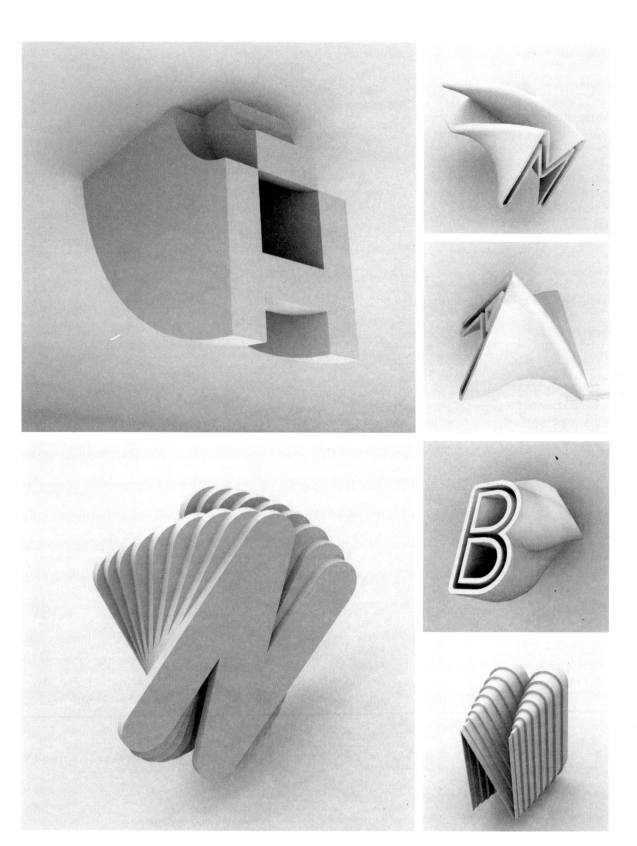

10 Punctuation

Punctuation is distinct from alphabetic and numerical characters in that it has no verbal equivalent. Characters such as the question mark and full stop are not spoken. These characters form part of written grammar, but are only imagined in speech. That is not to say that they are not represented in speech. They are implied through intonation and strategically placed pauses. Punctuation instructs the reader how to read a text aloud, providing vital information about how a written text may be communicated aurally.

With no direct spoken equivalent, punctuation marks that are used alone cannot communicate precise linguistic meaning, only linguistic intent. Although many of the typographic works that appear elsewhere in this book communicate linguistically as well as graphically, the examples contained within the following few pages contain no components that can be read out loud. They do, however, express sentiment. A question mark alone may not draw attention to a particular dilemma, but it does communicate a sense of uncertainty. Likewise, a lone exclamation mark does not tell us what to fear, but nevertheless makes the reader alert to potential danger.

The simplicity and symmetry of some punctuation marks make them ideal for repetition. However, as some artefacts show, the shape of a punctuation mark varies across typefaces as much as the shape of any alphabetic character. The extent of this variation is displayed in Jean-Marc Gerhards' *Favourite Punctuation* (overleaf). Gerhards' semi-opaque overlaid shapes reveal the dramatic differences between the contours of five common fonts, while also revealing some perhaps unexpected similarities: despite significant differences, many of these forms terminate in the same place.

Barbara Brownie
Quote
2009

favourite
punctuation
marks

no **1** question
mark

fonts

stempel garamond roman
palatino regular
itc bookman light

clarendon regular
cooper black

favourite
punctuation
marks

no **2** comma fonts neue helvetica bold stempel garamond roman
baskerville bold times new roman bold
bernard condensed bold

favourite
punctuation
marks

no **3** exclamation mark fonts stempel garamond bold cooper black
american typewriter bold clarendon bold
times new roman bold

Barbara Brownie
Floral Motifs
2009

Mohammad Hamad Zeinali
Dot Experience
2010
behance.net/emech

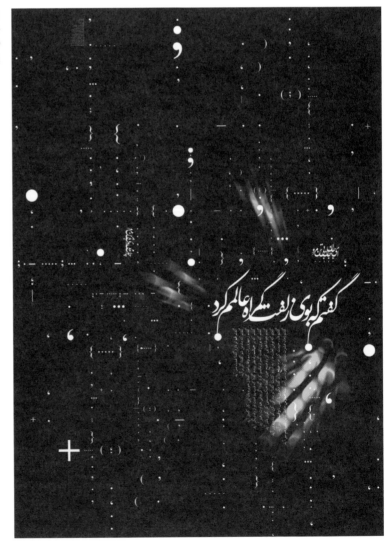

Barbara Brownie
Pow
2009

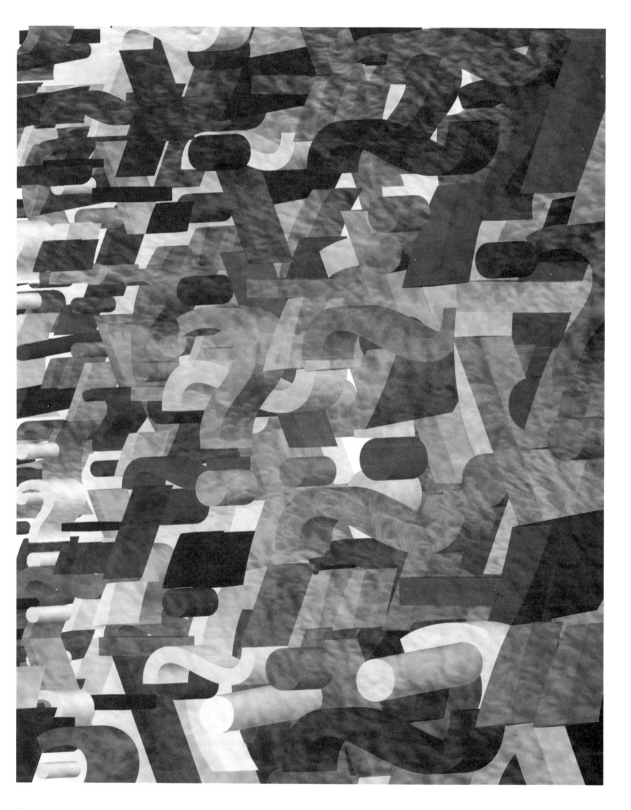

Barbara Brownie
Punctuate
2010

11 Images of Type

In digital environments, type is virtual. Its presence is fleeting and its appearance is changeable. When committed to paper, digital type becomes real, but also disposable. It is only rarely considered worthy of preservation. Historically, however, type has been an object: a metal or wooden block from which typographers could produce identical prints of a letter.

Since the introduction of digital word processors, a certain nostalgia has arisen for traditional printing methods, and associated paraphernalia. Traditionally produced prints, and the tools used in their production — lead type, wooden printing blocks, and even typewriters — have become collectors items. There is a tangibility to these objects that is lacking in digital environments. The permanence and perceived reliability of a tangible object, in contrast to the transience of a digital document, have led to a trend for the preservation and display of such objects. Printing blocks and metal type are now displayed as objects of beauty, rather than concealed in a draw alongside other tools of practical function.

Photographs of wooden and metal type, and typewriter elements, are records of traditional printing processes, but also seek to convey the beauty of their subjects. They are dynamically composed, or depict elements emerging from shadows. Printing blocks or metal type are illuminated so as to accentuate contours with shadow and highlight, embracing the idea of type as a physical object.

This willingness to accept the typographic form as more than a printed sign — as an object, with potentially all the physical characteristics of any other photographic subject — was established in 1925 when Laszlo Moholy-Nagy proposed that his "typophotos" were truer, more objective representations of type than print[1]. Though metal and wooden type are created with the intention of producing print, the printed letterform is only partly representative of type blocks. Print represents the carved surfaces of type blocks, but in reverse. A photo, however, represents many more characteristics of the original printing block, including its colour, surface texture, and three-dimensional form.

1 Moholy-Nagy, Laszlo, 'Typophoto', 1925, in Armstrong, Helen (ed.), Graphic Design Theory, Princeton Architectural Press, NY, 2009, pp. 33-34. p. 34.

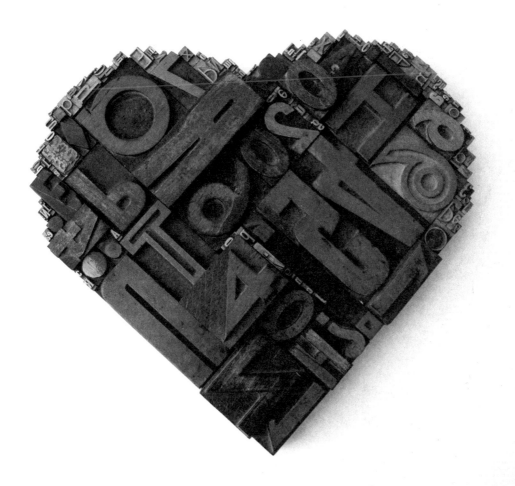

Manolo Guerrero
I Love Typography
2009
bluetypo.com

Barbara Brownie
Oi
2008

Cesar Esparza Bertuline
Typewriter
2008
cesaresparza.blogspot.com

Barbara Brownie
Postman's Broken Back
2009

Greg Meadows
Paradise Press No. 12
2008
www.HowGregSeesIt.blogspot.
com

Stephen E. Nigl
20th Century Word Processor
2006
adriftphotography.com

Stephen E. Nigl's *20th Century Word Processor* (left) is a tribute to one of the many typing technologies which have fallen by the wayside as they are superseded by more convenient or popular machines. IBM Selectric typewriters of the 1960s used a pivoting typeball. Nigl's image shows one such typeball, containing on its outer surface a full character set. Selectric type elements were interchangeable, allowing users to select from a range of alternative typefaces.

Richard Banks
Heart Type
2008
richardbanks.com

12 Conclusion

In an increasingly pictorial world, plain and static type has become less commonplace. Forced to compete with pictorial and temporal media, type has adapted to suit the demands of a new audience. Audiences are now less impressed by simplicity and legibility than they are by innovation and spectacle. Type should surprise its audience: push new boundaries; challenge expectations. It should defy established notions of the nature of type.

The categories explored in this book only begin to identify the numerous ways in this the alphabetic keyboard has been used as a tool for image-making. Typed forms may be treated as planar or volumic, they may be reductionist or elaborately decorated, and in each of these states they communicate a variety of different linguistic and pictorial messages.

Fundamental to the notion of the typed image is the acceptance of the alphabetic form as one that may communicate in two different ways simultaneously. The practitioners featured in this book identify the letter not only

as a sound but also as a shape. As a shape, the letter may be distorted and divided, rotated and extruded, coloured and decorated. The linguistic and pictorial messages communicated by a typographic artefact may work together to contribute to a shared message, with each reinforcing the other (as in Andrew Hall's *White Hand*, overleaf); or, the pictorial and linguistic messages may diverge, offering the audience a choice of different meanings. Whatever the relationship between the two messages, they are inextricably linked. The pictorial and linguistic messages cannot be divorced from one another. Where type is used in the construction of a portrait, or as an in-image caption, it can identify the preferred meaning, and perhaps even provide information about the subject that would not be clearly communicated through the medium of image alone.

In creating an artefact which straddles the divide between type and image, it is inevitable that legibility will often be sacrificed. Legibility is often not a priority for the Postmodern typographer. But illegibility and pictorial communication do not always

go hand-in-hand. In the typed image, letters do not always aim to conceal their true identity. The linguistic interpretation of a typed image is often vital to the understanding of the piece as a whole.

The existence of illuminated and iconographic lettering in previous centuries tells us that the typed image is not a technologically motivated phenomena. Indeed, technology may be partly responsible for establishing and reinforcing divisions between type and image.

However, contemporary software is evidently contributing to the recent popularity of typographic images. It is becoming increasingly easy to automate typographic images. Shape packing algorithms, like those used by ToDo Design (top right), demonstrate how typographics may now be generated rather than directly designed. Here, it is not the image that is typed, but the generative code. By varying values, it is possible to use the same code to generate any number of different typographic images.

The alphabet has escaped direct association with planar type. Letters are recognised not simply as printed signs, but also as abstract or pictorial forms, physical objects, and, as in Niamh Smith's *Omar* (below right) as negative spaces. Letters can play a role, adopting pictorial characteristics to masquerade as an image, or collaborating with other letters as the building blocks of a larger shape or scene, in which the pictorial whole is greater than the sum of its linguistic parts. Letters have escaped the confines of the page and screen, becoming sculptural objects.

The keyboard itself has become not only a means of producing type, but also of producing images. Pictorial forms may be assigned to keys, so that the typing process may generate entirely abstract or pictorial arrangements. Furthermore, the keyboard is now recognised as a thing of beauty in itself. They may be mechanical instruments, but alphabetic keys can also serve as decorative objects. They are treasured, as ornamental keepsakes, and photographed in soft light.

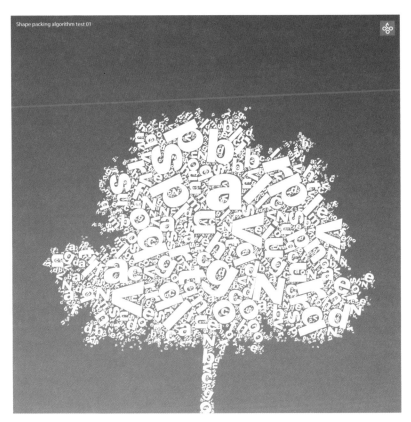

ToDo Design
Shape Packing Algorithm
2009
www.todo.to.it

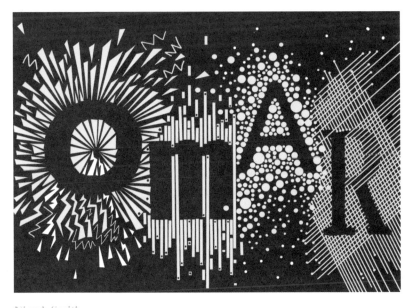

Niamh Smith
Omar
2009
littleredtreacle.com

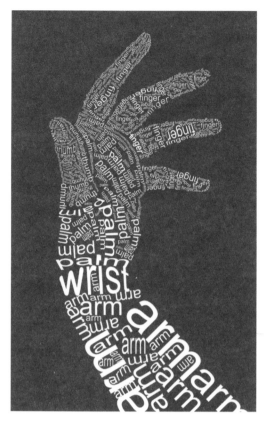

Andrew Hall
White Hand
2008
drybones90.deviantart.com

André Baumgart
Trust in You
2009
zeqzeq.deviantart.com

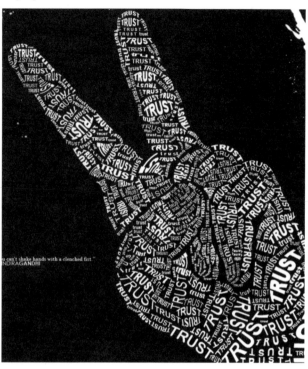

If we attempt to classify an artefact as either text or image, we find that there are many examples which fall into both categories, fulfilling criteria for both text and image; as is the case with picture poetry, calligrams, typewriter art, and many contemporary typographic experiments. Michael Biggs observes that "little work has been undertaken on the boundary between graphics and text", and there are therefore no "robust conditions to differentiate graphics from text"[1]. No format can be considered synonymous with either graphics or text, particularly in a digital context, where image files can often contain linguistic content. Neither can the method of creation define an artefact as text of image. As we have seen in this book, it is possible to create images using the keyboard. Moreover, it is possible to create entirely linguistic artefacts using traditionally pictorial creation methods, such as photography. If we cannot define an image as text or image at the point of creation, we must do so at the point of reception. It is the viewer, in receiving a typographic image, who perceives either a pictorial or linguistic message. Frequently, there are multiple messages, both linguistic and pictorial, and the viewer must rectify the relationship between the two. The typed image, in all its incarnations, is a transformation. It transforms type to image or image to type. It proves that, in defining type, we have reduced image and type to binary opposites, when there is in fact an analogue scale. Type can rarely, if ever, be described as devoid of pictorial meaning.

1 Biggs, Michael A. R., 'What Characterizes Pictures and Text?', Literary and Linguistic Computing, Vol. 19, No. 3, 2004, pp. 265-272

the quick brown fox jumped over the lazy dog

Anna Jacobs
The Quick Brown Fox
2009
behance.net/annajacobs

Leander Herzog
Cover for CACM Vol 51
2008
www.leanderherzog.ch

Corey Price
Sum of the Parts
2009
behance.net/coreyprice

Luke Kitt
Jenga Typeface
2009
www.lukekitt.com

January 2011